펴낸이 김기훈 김진희

펴낸곳 ㈜쎄듀/서울시 강남구 논현로 305 (역삼동)

발행일 2019년 11월 5일 제3개정판 1쇄

내용 문의 www.cedubook.com

구입 문의 콘텐츠 마케팅 사업본부

Tel. 02-6241-2007

Fax. 02-2058-0209

등록번호 제22-2472호

ISBN 978-89-6806-180-6

978-89-6806-178-3 (세트)

✦ Grammar is Understanding ✦

GRAMMAR Q

Advanced ②

GRAMMAR Q
Advanced 2

지은이	김기훈, 쎄듀 영어교육연구센터
디렉터	오혜정
편집	라임나무
마케팅	콘텐츠 마케팅 사업본부
영업	문병구
제작	정승호
인디자인 편집	올댓에디팅
디자인	윤혜영
일러스트	날램, 리지, 그림숲
영문교열	Adam Miller

Grammar Q 시리즈, 이렇게 바뀌었습니다.

대한민국 영어교육의 최전선에서 다년간 수많은 학생들을 지도해 오면서 얻은 교수 경험과 연구 성과를 바탕으로 만들어진 Grammar Q 시리즈는 출간 이후 우리나라 영어 학습 환경에 최적화된 교재로 자리매김하였습니다. 외국어로서의 진정한 영어 학습뿐만 아니라 효과적인 내신 대비를 위해 철저한 이론적 분석과 현직 교강사의 검토를 거쳐 만들어진 Grammar Q 시리즈가 더욱 알차게 바뀌었습니다.

새로워진 Grammar Q의 특징은 다음과 같습니다.

① 개정 교육과정 완벽 반영

개정 교육과정과 새로운 중학교 검정 교과서 10종을 연구하여 이를 토대로 Grammar Q의 수록 문법 규칙을 선정하였습니다. 개정 교육과정에 명시된 중학 수준에서 목표하는 문법 규칙을 모두 포함하고 있으며, 개정 후 중학 수준에서 배제되는 항목들은 중요도와 기출빈도를 고려하여 수록하였습니다.

● 기존 교육과정 ● 개정 교육과정

		초	중	고	수록 여부
If를 생략한 가정법	**Had I had** enough money, I **would have bought** a cell phone.		●	●	×
not A but B	He came **not** to complain, **but** to help us.		●	●	○

위와 같이 개정을 통해 중학교 교과과정에서 고등학교 교육과정으로 이동한 일부 문법 규칙은 중요도와 난이도, 기출빈도를 함께 분석하여 Grammar Q 시리즈에서 학습하기도 합니다.

② 최신 기출 유형 & 서술형 보강

전국의 중학교 1~3학년 내신 문법 문제를 취합·분석하여 신유형의 출제 경향을 반영했습니다. Unit마다 다양한 연습 문제 유형으로 문법 규칙을 바르게 이해하였는지 확인하고 실제와 유사한 수준의 최신 유형의 문제를 풀며 실전 감각을 키우도록 합니다. 또한, 서술형 문제의 중요도와 비율이 커지고 있음을 적극 반영하여 이를 충분히 연습할 수 있도록 구성했습니다.

③ 자세하고 친절한 설명

영어 자체를 이해하는 데 방해가 되는 어려운 용어 사용을 지양하고, 지나치게 간결하고 딱딱한 개념 설명은 아주 쉽고 친절하게 풀어 썼습니다. 또한, 흥미롭고 유익한 예문을 통해 설명함으로써 어려운 영문법에 쉽게 접근할 수 있습니다.

모든 학습자들이 새로워진 Grammar Q 시리즈와 함께 진정한 이해를 바탕으로 영문법을 체득하기를 바라며, 여러분의 GQ(문법활용능력지수)가 쑥쑥 올라 학업에 큰 정진이 있기를 기원합니다.

저자

PREVIEW

01 기본 개념&용어 Review

• 학습을 시작하기 전에 주요 개념을 한 눈에 살펴보세요.

❶ 그림, Q&A, 도식과 같은 다양한 구성으로 기본 개념에 쉽게 접근

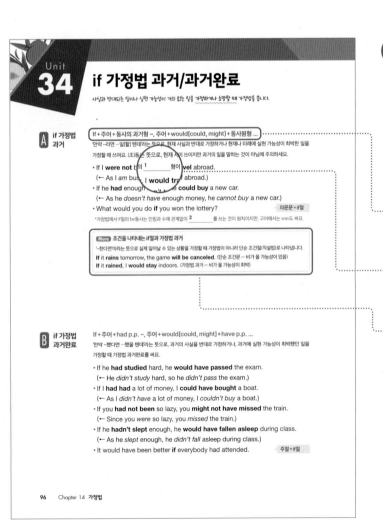

02 문법 개요

• 쉽고 친절한 설명과 실용적이고 자연스러운 예문으로 효과적인 학습이 가능해요.

❶ 문법 항목마다 이해를 돕기 위한 한 줄 핵심 요약

❷ 설명의 빈칸을 직접 채우며 공부할 수 있는 능동적 구성

❸ 놓치기 쉬운 심화 문법 포인트와 문제 풀이를 까다롭게 하는 주의 사항까지 학습

4

03 PRACTICE

- 신유형을 포함한 다양한 유형의 연습문제로
 학습 이해도를 확인합니다.

- 문제 난이도와 풀이 과정의 수준을 고려하여
 쉬운 문제부터 고난도 문제까지 단계적으로
 정복할 수 있도록 구성했습니다.

04 내신 적중 Point

- 최신 출제 경향을 반영한 포인트별 빈출 유형을 확인
 할 수 있습니다.

❶ 포인트별 대표 기출 문제에 대한 출제 의도와
 해결책 제시

PREVIEW

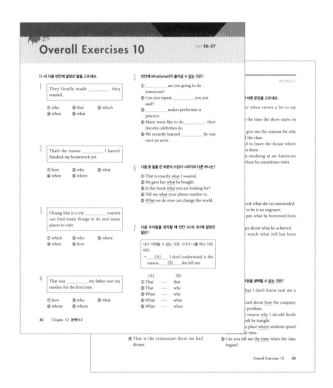

05 Overall Exercises

- 여러 문법 사항을 한데 통합한 문제로 실전에 대비합니다.

- 이전 챕터의 내용이 자연스럽게 반복되어 누적학습 효과를 보입니다.

06 Writing Exercises

- 영작을 통해 학습한 규칙을 적용해보세요.

- 시험에 꼭 나오는 서술형 문제로 완벽한 내신 대비가 가능합니다.

07 Workbook

- 서술형을 포함한 다양한 유형의
 추가 문제로 충분한 연습과 복습을
 할 수 있습니다.

1. 어휘리스트

2. 어휘테스트

3. 예문응용문제

4. 예문영작연습지

5. 예문해석연습지

6. 서술형 추가문제

7. 종합평가

8. Study Planner

학습을 돕는 다양한 무료 부가 학습자료

www.cedubook.com에서 다운로드 하세요.

CONTENTS

Advanced 2

Advanced 1

CHAPTER

09

관계사 1

| 기본 개념 & 용어 Review |

관계대명사 관계대명사가 이끄는 절은 선행사를 수식하는 형용사 역할을 해요.

선행사 관계대명사절

선행사의 종류와 격에 따라 알맞은 관계대명사를 써야 해요.

사람 선행사 + who, whom, that

사물·동물 선행사 + which, that

관계대명사 앞에 콤마(,)가 있으면 선행사에 대한 부가적인 정보를 나타내요.

선행사 , 관계대명사

관계대명사가 이끄는 절은 선행사를 수식하는 형용사 역할을 하며, 수식받는 명사가 사람일 때는 who, whom, whose, that을 써요.

A 관계대명사의 역할

관계대명사 = 「접속사 + 대명사」

관계대명사는 두 문장을 연결해주는 접속사 역할을 하며, 선행사를 수식하는 절을 이끌어요. 이때 관계대명사는 대명사 역할도 하므로 관계대명사절 내에 대명사를 중복해서 쓰지 않아야 해요.

I met my friends. + I hadn't seen them(= my friends) for a long time.
→ I met *my friends* **whom** I hadn't seen them for a long time.
선행사 └─────────────┘ 관계대명사절

B 주격 관계대명사 who, 목적격 관계대명사 whom

관계대명사 who는 관계대명사절에서 주어 역할을 하며 that을 대신 쓰기도 해요. whom은 관계대명사절에서 목적어 역할을 하는데, who나 that을 대신 쓰는 경우가 많아요. 이때 목적격 관계대명사로 쓰인 whom, who, that은 생략할 수 있습니다.

- I have *an uncle*. + *He* lives in Vancouver.
 → I have *an uncle* **who[that]** lives in Vancouver. ◂ 주격 관계대명사 who[that]
- I remember **those who** were at the party. ◂ 주격 관계대명사 who
 = the people who(~한 사람들)
- That's *the girl*. + I often see *her* on my way home.
 → That's *the girl* (**whom**) I often see on my way home.
 ◂ 목적격 관계대명사 whom
- J.K. Rowling is *the writer* (**that**) I like best. ◂ 목적격 관계대명사 that

> **More** 관계대명사절의 수일치
> - 주격 관계대명사절 내의 동사는 선행사에 수일치시켜요.
> Did you see *the child* **who was** wearing a blue T-shirt?
> - 선행사가 문장의 주어일 때 멀리 떨어져 있는 동사의 수일치에 주의하세요.
> *A man* **who** wants to see you **is** waiting outside.

C 소유격 관계대명사 whose

「선행사 + whose + 명사 + 동사 ~」

관계대명사 whose는 관계사절에서 소유격을 대신하는데, 선행사가 무엇이든 상관없이 쓸 수 있어요. whose 뒤에는 반드시 명사가 따라옵니다.

- There was *a king*. + *His* name was Midas.
 → There was *a king* **whose** name was Midas. ◂ 소유격 관계대명사
- I saw *a house*. + *Its* roof is red.
 → I saw *a house* **whose** roof is red.

*whose는 of which로도 바꿔 쓸 수 있지만 of which는 주로 글에서 쓰여요.

PRACTICE

STEP 1

주어진 두 문장을 한 문장으로 바꿔 쓸 때 빈칸에 알맞은 관계대명사를 〈보기〉에서 골라 쓰세요.
(알맞은 관계대명사가 둘 이상인 경우도 있음)

〈보기〉	who	whom	whose	that

1 I still remember the boy. He lent me his umbrella.

→ I still remember the boy _____ lent me his umbrella.

2 I know a girl. Her father is a famous movie star.

→ I know a girl _____ father is a famous movie star.

3 She received a thank-you letter from the boy. She gave him some advice.

→ She received a thank-you letter from the boy _____ she gave some advice.

4 We are looking for a man. His name is Gary.

→ We are looking for a man _____ name is Gary.

5 Cinderella is a fairy-tale character. She marries a prince.

→ Cinderella is a fairy-tale character _____ marries a prince.

6 The police officer told us how to get there. We asked him for directions.

→ The police officer _____ we asked for directions told us how to get there.

STEP 2

굵은 글씨로 된 관계대명사가 생략 가능하면 ○, 그렇지 않으면 ✕를 쓰세요.

1 A friend is a person **who** you can depend on when you are in trouble.

2 The Turkish Angora is a cat **whose** fur is white and silky.

3 The girls **that** I mentioned in my letter are coming tonight.

4 I always enjoy meeting people **whose** cultures are very different from mine.

5 Mahatma Gandhi was a leader **who** hated violence.

PRACTICE

STEP 3

괄호 안에서 어법에 맞는 것을 모두 고르세요.

1 I want to have a friend who [make / makes] me happy.

2 People who [reserve / reserves] the train ticket online can get a 10% discount.

3 Those who listened to her speech [was / were] deeply moved.

4 The soccer player who we like the most [is / are] from Barcelona.

5 He wants to marry someone [who / whom] understands him well.

6 There are four students in my class [who / whose / that / 생략 가능] speak Chinese.

7 The people [who / whom / that / 생략 가능] I waved at are my neighbors.

8 The doctor was talking to the patient [who / whose / that / 생략 가능] leg was broken.

STEP 4

밑줄 친 부분이 어법에 맞으면 ○, 틀리면 ✕를 하고 바르게 고치세요.

1 Those <u>whose</u> disagree with the new policy will not change their mind.

2 Spectators who came to see the soccer game <u>were</u> cheering for their team.

3 The expert who <u>he</u> works for an advertising company will give us a lecture.

4 Mr. Carter is the teacher <u>who</u> every student loves for his sense of humor.

5 Someone <u>who</u> accent sounded foreign called you an hour ago.

6 Scientists who <u>was</u> studying elephants did an experiment.

7 Her grandfather was the person who Jane respected <u>him</u> the most in the world.

내신 적중 Point

Point 01 쓰임이 잘못된 것 찾기

각 관계대명사의 쓰임을 구분할 수 있어야 해요. 특히 주격, 목적격 둘 다로 쓰일 수 있는 관계대명사에 주의하세요.

Point 02 빈칸에 공통으로 들어갈 말 찾기

선행사가 무엇인지와 관계대명사가 관계대명사절 안에서 무슨 역할을 하는지 파악해야 해요.

Point 03 생략할 수 없는 것 고르기

주격과 목적격 중 관계대명사를 생략할 수 있는 경우를 구분해야 해요.

정답 및 해설 p.2

Point 01

● 밑줄 친 관계대명사의 쓰임이 바르지 <u>않은</u> 것은?

① I don't know the people <u>who</u> you are talking about.

② I know the girls <u>that</u> are playing basketball in the gym.

③ Sam is the person in the office <u>that</u> got a bonus this year.

④ There are several students in my class <u>whose</u> want to study Spanish.

⑤ We'll have dinner at the restaurant <u>whose</u> chef won the cooking contest.

Point 02

● 다음 빈칸에 공통으로 들어갈 말로 알맞은 것은?

• I will never forget those _____ went through difficulties with me.

• She is the woman _____ you saw on TV.

① who ② whom ③ whose ④ them ⑤ which

Point 03

● 다음 중 밑줄 친 부분을 생략할 수 <u>없는</u> 것은?

① The woman <u>whom</u> I love most is my grandma.

② Phil is the friend <u>that</u> I can depend on.

③ The person <u>who</u> didn't say a word at the meeting was Mike.

④ Who is the boy <u>that</u> the teacher is talking to?

⑤ She has a little sister <u>who</u> she has to take care of.

관계대명사 which, that

선행사가 사람 이외의 것(사물, 동물 등)일 때는 관계대명사 which와 that을 쓰는데, that은 소유격을 제외하고
모든 관계대명사 대신 쓸 수 있어요.

A 관계대명사 which

관계대명사 which

관계대명사 which는 주격과 목적격의 형태가 같으며, which 대신 that도 쓸 수 있어요. 목적격으로 쓰인 관계대
명사는 일상생활에서 생략하는 경우가 많아요.

• This is *the road*. + *It* leads to the park.
 → This is *the road* **which**[**that**] leads to the park. 　　　주격

• *The fish* was very big. + I caught *it* yesterday.
 → *The fish* (**which**[**that**]) I caught yesterday was very big. 　목적격

• There is *a girl and a dog*. + *They* are walking in the park.
 → There is *a girl and a dog* **that** are walking in the park. 　「사람+동물」선행사

B that의 여러 가지 쓰임

❶ 주격 관계대명사 vs. 목적격 관계대명사

that은 선행사에 관계없이 주격, 목적격으로 모두 쓸 수 있으므로 잘 구별해야 해요.
관계대명사절에서 주어나 목적어가 생략된 자리(●)를 보고 관계대명사의 격을 구분할 수 있습니다.

• They're looking for a person **that** ● <u>can speak</u> French. 　주격
 　　　　　　　　　　　　　　　　　　　　동사

• She lost her necklace **that** <u>she</u> <u>bought</u> ● last week. 　목적격
 　　　　　　　　　　　　　　　주어　　동사

❷ 관계대명사 vs. 접속사 vs. 지시대명사[지시형용사]

관계대명사 that은 뒤에 불완전한 구조가 오지만 접속사 that은 뒤에 완전한 구조의 절이 와요.

• The boy **that** ● <u>is standing</u> over there is my brother.
 　　　　　　　　동사 → 주어가 없는 불완전한 구조 　　　주격 관계대명사

• This is the book **that** <u>I</u> <u>have wanted</u> ●. 　목적격 관계대명사
 　　　　　　　　　　　주어　　동사 → 목적어가 없는 불완전한 구조

• I learned from his e-mail **that** <u>he</u> <u>was</u> in New York. 　명사절 접속사
 　　　　　　　　　　　　　　　　주어　동사　부사구 → 완전한 구조

• I found a nice tie and decided to buy **that** for my dad.
 　　　　　　　　　　　　　　　　　　　　　　지시대명사: 저것[저 사람]

• Did you see **that** boy cheating on the exam? 　지시형용사: 저[그] ~

PRACTICE

STEP 1

다음 괄호 안에서 어법에 맞는 것을 모두 고르세요.

1 The books which were written by Douglas Kennedy [is / are] my favorite.

2 Where is the bottle of milk [who / which / that / 생략 가능] I bought yesterday?

3 The only thing that you have to do [is / are] just to wait for her call.

4 Why did you buy shoes [who / which / that] are too small for you to wear?

5 The only pet [who / whose / that] I have ever had was a hamster.

6 He owns a Picasso painting [whose / which / that / 생략 가능] value is more than ten million dollars.

7 This is the train [who / whose / that / 생략 가능] passes through 12 states of India.

8 He was reading a magazine [whose / which / that / 생략 가능] cover had a picture of a beautiful garden.

STEP 2

밑줄 친 that이 관계대명사와 접속사 중 어느 것으로 쓰였는지 고르세요.

1 I have a good friend that always walks to school with me. [관계대명사 / 접속사]

2 I believe that you will keep your promise. [관계대명사 / 접속사]

3 The problem is that we don't have enough time. [관계대명사 / 접속사]

4 The coffee machine that we use every day is very convenient. [관계대명사 / 접속사]

5 The movie that she wants to see will be released tomorrow. [관계대명사 / 접속사]

PRACTICE

정답 및 해설 p.2

STEP 3

밑줄 친 단어의 쓰임을 〈보기〉에서 골라 그 기호를 쓰세요.

〈보기〉 ⓐ 관계대명사 ⓑ 명사절 접속사 ⓒ 지시대명사 ⓓ 지시형용사

1 I visited a winery in France and met the woman that makes the wine.

2 She's talking to that person with a walking stick over there.

3 Is that your T-shirt on the chair? Put it in the washing machine.

4 It is one example of the methods that help people overcome depression.

5 We couldn't believe that the charming guy got arrested.

STEP 4

다음 우리말과 같도록 괄호 안의 단어를 배열하여 문장을 완성하세요.

1 이것이 그들이 숨기려고 애썼던 진실이다. (tried to, which, the truth, is, they, hide)

→ This _____.

2 Machu Picchu는 내가 가보고 싶어 하는 곳이다. (the place, I, want, is, to visit, that)

→ Machu Picchu _____.

3 그녀의 남편이 빌렸던 그 차는 신형이었다. (which, was, her, brand new, rented, husband)

→ The car _____.

4 우리 병원에 매년 많은 돈을 기부하는 사람이 있다. (donates, a person, lots of money, that)

→ There is _____ every year to our hospital.

Unit 24

내신
적중
Point

Point 01 빈칸에 알맞은 말 찾기

학습한 여러 관계대명사의 쓰임을 구별하여 알맞은 것을 사용할 수 있어야 해요.

Point 02 쓰임이 같은 것 찾기

that이 관계대명사인지 접속사인지 that 뒤의 구조를 보고 판단하세요.

정답 및 해설 p.3

Point 01

● 다음 빈칸 (A)~(C)에 들어갈 말로 바르게 짝지은 것은?

> • The spaghetti _____ (A) _____ my brother made was really delicious.
> • I have a dog _____ (B) _____ name is Honggu.
> • Look at the picture of a man and a horse _____ (C) _____ are crossing the river.

	(A)		(B)		(C)
①	which	······	that	······	which
②	that	······	which	······	whose
③	who	······	whose	······	whom
④	which	······	whose	······	that
⑤	who	······	which	······	who

Point 02

● 다음 중 〈보기〉의 that과 쓰임이 같은 것은?

> 〈보기〉 The prince is doing the military service that the king also did twenty years ago.

① The travel agent advised me that my trip would be quite expensive.

② That is the school the current president studied at.

③ The story that I read yesterday was very moving.

④ He tried to train that dog because it barked so loudly.

⑤ It is certain that there is a shortage of job opportunities.

Unit 24 **21**

Unit 25 관계대명사의 계속적 용법

관계대명사가 이끄는 절은 선행사를 수식하여 의미를 제한하기도 하고, 이미 알고 있는 선행사에 대해 추가적인 정보를 덧붙이는 역할도 해요.

A 관계대명사의 계속적 용법

관계대명사 바로 앞에 콤마(,)를 두면 선행사에 대한 부가적인 설명

선행사만으로는 무엇을 나타내는지 그 의미가 모호한 경우, 관계대명사를 사용하여 선행사에 대한 필수적인 정보를 줄 수 있어요.

• This is *the photo*.　　　　　　　　　　　　　　어떤 사진을 말하는 것인지 모호

　→ This is *the photo* **which** shows my classmates.

　　　　　　　　　　　　　　　　　　　　반 친구들을 보여주는 사진 → 의미 제한됨

반면, 선행사를 이해하는 데 꼭 필요하지는 않지만 부가적인 정보를 덧붙일 때, 관계대명사 바로 앞에 콤마(,)를 써서 나타낼 수 있어요. 이러한 쓰임을 계속적 용법이라고 해요.

• I went to the park, **which** was so crowded.　부가 정보(필수적이지 않음)

> **More** 계속적 용법의 주의할 점
> • 계속적 용법의 관계대명사는 생략할 수 없어요.
> 　I studied at the library with Jen, helped me with my homework. (×)
> 　　　　　　　　　　　→ ~ Jen, **who** helped me with my homework. (○)
> • 관계대명사 that은 계속적 용법으로 쓰지 않아요.
> 　He bought me a new sweater, **that** was too small for me. (×)
> 　　　　　　　　　　　→ ~, **which** was too small for me. (○)

B 계속적 용법의 선행사

계속적 용법으로 쓰인 관계대명사는 「접속사+대명사」의 의미를 나타내는데, which는 어구나 앞의 절 전체를 선행사로 취하기도 합니다.

I ate *curry*, **which**(= and it) is my favorite food.

I visited *my uncle*, **who**(= but he) was not at home.

These gloves, **which**(= and them) my mom made me, are warm.

I congratulated *Susan*, **whose**(= because Susan's) son had passed the exam.

He said that *he met her*, **which**(= but it) was a lie.　　선행사 = 어구

He kept lying, **which**(= and it) made me angry.　　선행사 = 앞의 절 전체

PRACTICE

정답 및 해설 p.3

STEP

1

관계대명사절을 이용하여 주어진 두 문장을 한 문장으로 바꿔 쓰세요.

1 I share a room with my brother. He is three years older than me.

→ I share a room with my brother, _____ .

2 The word *jumbo* comes from the name of a famous elephant Jumbo. It means "very big."

→ The word *jumbo*, _____ comes from the name of a famous elephant Jumbo.

3 He has a print by Andy Warhol. But it is not an original.

→ He has a print by Andy Warhol, _____ .

4 Ali is my best friend. Everyone wants to make friends with him.

→ Ali is my best friend, _____ .

5 11th Avenue was dangerous. He was driving on it.

→ 11th Avenue, _____ , was dangerous.

6 He said that he finished the task an hour ago. It was not true.

→ He said that he finished the task an hour ago, _____ .

7 Thor is Odin's son. He is the strongest god of all.

→ Thor, _____ , is the strongest god of all.

8 Kate enjoyed the blueberry pancakes. Her mother made them this morning.

→ Kate enjoyed the blueberry pancakes, _____ .

9 The old man was a famous author. I asked him for some advice.

→ The old man, _____ , was a famous author.

10 Look at the tall boys. They are dancing on the stage.

→ Look at the tall boys, _____ .

11 Two letters were found in the old box. They were written in Japanese.

→ Two letters, _____ , were found in the old box.

PRACTICE

STEP 2

밑줄 친 부분이 어법에 맞으면 ○, 틀리면 ×를 하고 바르게 고치세요.

1 The artist thanked the audience, <u>and who</u> clapped loudly.

2 Where did you put the sweater <u>was made</u> for Jim?

3 I walked to the lake, <u>that</u> always makes me feel calm.

4 Both of the leaders wanted to stop the war <u>which was destroying</u> their countries.

5 Her husband was snoring, <u>which</u> was the cause of her sleeplessness.

6 The Busan International Film Festival, <u>that</u> is held every year in Busan, is popular among the locals and tourists.

STEP 3

밑줄 친 부분 중 생략할 수 <u>없는</u> 것은?

① The president <u>whom</u> many people had respected died.
② The woman <u>who</u> Tom is talking to is my aunt.
③ He passed the ball to Ronaldo, <u>who</u> missed it.
④ This book is the one <u>which</u> he is searching for.
⑤ Do you know the news <u>that</u> she was surprised at?

STEP 4

우리말과 뜻이 같도록 괄호 안의 단어를 이용하여 문장을 완성하세요. (콤마(,)와 관계대명사를 사용할 것)

1 Sam은 Jenny와 결혼했는데, 그녀의 어머니는 작가이다. (mother, a writer)

→ Sam married _____ .

2 'Men in Black'은 내가 가장 좋아하는 영화인데, 나는 그것을 지금까지 여섯 번 봤다.
(six times, have watched, my, so far, favorite movie)

→ *Men in Black* is _____ .

3 Dave는 항상 회의에 늦는데, 그게 우리를 짜증나게 만든다. (us, makes, annoyed, meetings)

→ Dave is always late for _____ .

내신
적중

Point

Point 01 바르게 짝지어진 것 찾기

선행사를 파악하여 계속적 용법으로 쓰이는 알맞은 관계대명사를 골라야 해요.

Point 02 어법상 틀린 문장 찾기

계속적 용법으로 쓸 수 없는 관계대명사가 있음에 유의하세요.

Point 03 두 문장을 한 문장으로 만들기

콤마(,)와 알맞은 관계대명사를 사용하여 계속적 용법의 문장을 쓸 수 있어야 해요.

정답 및 해설 p.3

Point 01

● 다음 빈칸에 알맞은 말로 바르게 짝지어진 것은?

> This house has a bedroom, _____ faces south.
> I had two sons, _____ became teachers.

① that – which ② what – that
③ whom – that ④ who – which
⑤ which – who

Point 02

다음 중 밑줄 친 부분이 어법상 틀린 것은?

① She visited the country <u>that</u> she always dreamed about.
② I'm reading the book <u>which</u> you told me about before.
③ Mr. Smith, <u>who</u> is a well-respected teacher, has just retired.
④ Do you remember <u>the boy we</u> met at the park yesterday?
⑤ Sally didn't like the color of the bag, <u>that</u> I gave her for her birthday.

Point 03

서술형 ▶

● 주어진 두 문장을 관계대명사를 사용하여 한 문장으로 쓰세요. (단, 계속적 용법으로 쓸 것)

> I forgot that boy's name.
> It starts with C.

→ _____.

[1-4] 다음 빈칸에 공통으로 들어가기에 알맞은 말을 고르세요.

1
- The bus _____ goes to Seoul station is coming.
- This is my father's new car, _____ he bought last week.

① who ② that ③ whose
④ whom ⑤ which

2
- I saw a man _____ hair came down to his waist.
- That boy is Billy, _____ sister is a college student.

① who ② whose ③ whom
④ that ⑤ which

3
- He gave a ring to the woman _____ he fell in love with.
- It is true _____ some students cheated on the exam.

① which ② who ③ that
④ those ⑤ whom

4
- The lady _____ is waiting for the bus is Ms. Roberts.
- They found Matt, _____ was sleeping at home.

① who ② which ③ that
④ whose ⑤ whom

5 빈칸에 들어갈 말이 나머지와 <u>다른</u> 하나는?

① The chairs which Tim made _____ very comfortable.
② The men who _____ planning to open a restaurant didn't have enough money.
③ The boy who played soccer with us _____ Sam's brother.
④ I've found the book that you _____ looking for yesterday.
⑤ I met a man whose sons _____ all married.

6 다음 밑줄 친 부분 중 생략할 수 <u>없는</u> 것은?

① I have a friend <u>who</u> can cook Thai food.
② The girl <u>whom</u> you met yesterday is Ken's sister.
③ This is the bag <u>which</u> I want to buy.
④ Look at the boy <u>that</u> she is talking to.
⑤ I went to the bakery <u>which</u> you recommended.

7 다음 두 문장을 한 문장으로 바꿔 쓸 때 빈칸에 알맞은 말을 쓰세요. (계속적 용법으로 쓸 것)

> I was born in Sokcho. It is famous for its beautiful beach.

→ I was born in _____
_____.

8 밑줄 친 부분의 역할이 다음 문장의 <u>that</u>과 같은 것은?

> They live in a house <u>that</u> has a big living room.

① <u>That's</u> my brother Jimmy's cell phone.
② Harry promised <u>that</u> he would give me a call today.
③ <u>That</u> museum is one of the city's biggest tourist attractions.
④ The good news is <u>that</u> Grace is feeling better now.
⑤ I know some ghost stories <u>that</u> are connected with our school.

9 다음 우리말과 뜻이 같도록 괄호 안의 단어와 관계대명사를 사용하여 문장을 완성하세요.

> 그녀는 Jack을 찾고 있는데, 그는 공항으로 곧 떠날 것이다. (for the airport, will, leave)

→ She's looking for _____
_____ soon.

10 밑줄 친 관계대명사의 쓰임이 **틀린** 것은?

① I met the guy <u>who</u> Carrie is married to.
② He will have lunch with his friend <u>whose</u> comes from France.
③ I think he was the only candidate <u>that</u> was honest.
④ Is there anyone <u>whose</u> cell phone works well here?
⑤ Anna is the singer of the band <u>which</u> was very popular in the U.K.

[11-12] 다음 중 어법상 바른 문장을 고르세요.

11 ① He shared everything he loved with me.
② I started to learn Spanish, Mr. Hans teaches.
③ Those who took part in the Olympics is invited to a dinner.
④ This is my new neighbor whom moved in last month.
⑤ The information that I searched for on the Internet were needed for my essay.

12 ① Ted, that lives next door, plays soccer with me every Sunday.
② My favorite poet is Yun Dong-ju, which wrote "Sky, Wind, and Stars."
③ I saw a big spider, which I'd never seen before.
④ The salesperson, who she wants to be a millionaire, buys lottery tickets every week.
⑤ Lisa got a prize in an English speaking contest, that made her study English harder.

13 다음 문장을 어법에 맞게 고친 것은?

> That is my sister Amy, that personality is different from mine.

① That is my sister Amy, who personality is different from mine.
② That is my sister Amy, whom personality is different from mine.
③ That is my sister Amy, whose personality is different from mine.
④ That is my sister Amy, which personality is different from mine.
⑤ That is my sister Amy, personality is different from mine.

[14-15] 빈칸 (A)와 (B)에 들어갈 말이 바르게 짝지어진 것을 고르세요.

14

• Here is the book _____(A)_____ you asked for.
• Do you remember the girl _____(B)_____ I was talking about?

 (A) (B)
① who ······ that
② whose ······ who
③ which ······ that
④ whom ······ who
⑤ that ······ which

15

• He is moving to Austin, _____(A)_____ is in Texas.
• There is a woman and her dogs _____(B)_____ are taking a walk on the beach.

 (A) (B)
① who ······ who
② who ······ which
③ which ······ whom
④ which ······ that
⑤ that ······ whose

[16-17] 다음 중 어법상 틀린 문장을 고르세요.

16
① Whose is the car that is parked here?
② Bill lived in the house which roof was red.
③ This is Ms. Kim, whom you met last year.
④ They are the people who take part in the London Marathon.
⑤ A koala is known as a lazy animal which sleeps a lot.

17
① The house we're looking for are located in the center of the city.
② Matt is the one whose desk is next to mine.
③ Tony finished his project, which made him happy.
④ She is the girl whom I told you about.
⑤ She has a sports car whose color is yellow.

18 밑줄 친 부분의 쓰임이 다른 하나를 고르세요.

① I enjoyed the novel that you gave me as a birthday gift.
② The steak that my dad made for dinner was delicious.
③ She showed me her puppy that she is raising at home.
④ We saw a woman and a cat that were on the bench.
⑤ He suddenly realized that he made a huge mistake.

[19-20] 다음 문장에서 어법상 틀린 곳을 찾아 바르게 고치세요.

19

History is the subject which I like it best.

_____ → _____

20

Jean Valjean was very hungry, that led him to steal the bread.

_____ → _____

Writing Exercises

1 다음 우리말과 같은 뜻이 되도록 괄호 안의 단어를 배열하여 문장을 완성하세요.

(1)
> 그 모임에 참석했던 사람들은 모두 여성이었다.
> (who, were present, those, at the meeting, were)

→ _____
 all women.

(2)
> 나는 내 지갑을 발견한 사람이 그것을 되돌려 주면 좋겠다.
> (that, my wallet, the person, found)

→ I hope that _____
 will return it.

(3)
> 나는 지민이를 좋아하는데, 그는 우리 학교에서 인기가 있다.
> (like, is, who, popular, at my school, Jimin)

→ I _____.

2 다음 문장을 관계대명사를 사용하여 바꿔 쓰세요.
(반드시 콤마(,)를 사용할 것)

> The word *shampoo* comes from the Hindi word *champo*, and it means "to press."

→ _____

3 다음은 그리스 신화에 등장하는 Hercules와 Hydra의 그림입니다. 주어진 표현을 사용하여 이를 묘사하는 글을 완성하세요.

Hercules Hydra

> • was the son of Zeus
> • had many heads

→ Hercules, _____, was the strongest god in Greek myths. He fought the Hydra, _____.

4 우리말과 일치하도록 〈조건〉에 맞게 문장을 완성하세요.

> 〈조건〉
> • 괄호 안의 단어를 사용하여 7 단어로 쓸 것
> • 알맞은 관계대명사를 사용할 것

우리는 9시에 출발하는 기차를 타야 한다.
(should, leave, take the train)

→ _____
 _____ at nine o'clock.

CHAPTER

10

관계사 2

| 기본 개념 & 용어 Review |

what 선행사를 포함하는 관계대명사 what은 '~하는 것(들)'로 해석해요.

what = the thing(s) that[which]

what이 이끄는 관계대명사절은 문장에서 주어, 목적어, 보어로 쓰인답니다.

관계부사 관계부사는 두 문장을 연결하는 접속사이자 부사 역할을 해요.

관계대명사 what

앞에서 학습한 관계대명사절은 형용사처럼 선행사를 수식하는 반면, 관계대명사 what이 이끄는 절은 문장에서 명사처럼 쓰여요.

A 형태와 역할

❶ what = the thing(s) that[which]

관계대명사 what은 선행사 the thing(s)을 포함하며 '~하는 것(들)'의 뜻이 됩니다.

* **What** matters most is good health.
 = **The thing that** matters most is good health.
* I gave her **what** she needed.
 = I gave her **the thing(s) that** she needed.

> **More** 선행사와 함께 쓰지 않는 관계대명사 what
> 수식 받는 선행사가 있을 때는 what을 쓸 수 없어요.
> I don't believe *the rumor* what(→ which[that]) she told me.
> I don't believe **what** she told me.

❷ what이 이끄는 절은 문장에서 명사 역할

관계대명사 what이 이끄는 절은 문장에서 명사처럼 쓰여 주어, 목적어, 보어 역할을 한답니다.

* ***What** he said* is true.	주어
* You must not forget ***what** I told you*.	동사의 목적어
* I'm satisfied with ***what** he did*.	전치사의 목적어
* The result was ***what** I had expected*.	보어

B 관계대명사 what과 혼동하기 쉬운 것

❶ 관계대명사 what vs. 접속사 that

뒤에 오는 절이 불완전한 구조이면 관계대명사 what을, 완전한 구조이면 접속사 that을 써요.

* **What** <u>*he wants*</u> ● is her love. 관계대명사 what
 S V → 목적어가 없는 불완전한 구조
* I believe **that** <u>*he loves her*</u>. 접속사 that
 S V O → 완전한 구조

❷ 관계대명사 what vs. 의문사 what

관계대명사는 '~하는 것(들)', 의문사는 '무엇'으로 해석하는데, 문장 구조로는 구별할 수 없고 문맥을 통해 구별해야 해요. 하지만 두 가지 해석이 모두 가능할 때도 있습니다.

* I don't like **what** he says. 그가 말하는 **것**: 관계대명사
* She didn't tell me **what** her name is. 그녀의 이름이 **무엇**인지: 의문사
* Tell us **what** we should do next. 다음에 해야 하는 **것**: 관계대명사
 다음에 **무엇**을 해야 할지: 의문사

PRACTICE

STEP 1

관계대명사 what을 이용하여 주어진 두 문장을 한 문장으로 바꿔 쓰세요.

1 I heard something. I can't believe it.

→ I can't believe _____ .

2 He said something about his career. It cannot be true.

→ _____ cannot be true.

3 He had something in his hand. It was a ring for her.

→ _____ a ring for her.

4 I received something from my teacher. Here it is.

→ Here is _____ .

5 You learn something every day. To get a good grade, you should review it.

→ To get a good grade, you should review _____ .

STEP 2

괄호 안에서 어법에 맞는 것을 고르세요.

1 Did you hear [what / which] they said?

2 Have you ever watched a movie [what / which] was so boring that you fell asleep?

3 The man believed [what / that] there was treasure on the island.

4 This booklet shows [what / which] he is going to present at the meeting.

*booklet: 소책자

5 Steven is making a film [what / that] has many action scenes.

6 This painting is [what / that] the collector was looking for.

7 I like the song [what / which] is often used in TV ads.

*ad(= advertisement): 광고

8 [Which / What] you believe is not always right.

9 My essay is about [what / that] we can do to save the Earth.

10 She thinks [that / what] he is trying to hide his secret from others.

PRACTICE

정답 및 해설 p.4

STEP 3

다음 물음에 답하세요.

1 밑줄 친 what의 쓰임이 주어진 문장과 같은 것은?

> What I want to know is the bus fare to Incheon International Airport.

① She didn't know what it was.
② Can you tell me what your job is?
③ We must do first what is urgent.
④ Nobody could tell what they were.
⑤ I sometimes imagine what I will become in the future.

2 다음 중 빈칸에 들어갈 말이 바르게 짝지어진 것은?

> • Take this money and buy the one _____ you like.
> • The witness told the police about _____ she saw that day.

① that ······ what
② that ······ which
③ who ······ which
④ which ······ that
⑤ what ······ that

STEP 4

우리말과 뜻이 같도록 괄호 안의 단어를 배열하여 문장을 완성하세요.

1 아무도 그녀가 말한 것을 믿지 않는다. (she, believes, said, what)

→ No one _____.

2 그것은 내가 말하려던 것이 아니었다. (I, was, what, meant, not, to say)

→ That _____.

3 그를 좌절하게 하는 것은 그가 그녀를 더는 만날 수 없다는 것이다.

(makes, is, frustrated, him, what)

→ _____ that he can't meet her anymore.

34 Chapter 10 관계사 2

Unit 26

내신 적중 Point

정답 및 해설 p.5

Point 01

● 밑줄 친 what의 쓰임이 주어진 문장과 같은 것은?

I'll order <u>what</u> she ordered.

① <u>What</u> do you like to do in your free time?
② We didn't know <u>what</u> his intention was.
③ You'd better check <u>what</u> the noise is.
④ <u>What</u> you have learned may not always be true.
⑤ <u>What</u>'s wrong with your cell phone?

Point 02

● 다음 중 밑줄 친 부분이 어법상 틀린 것은?

① Is this <u>what</u> you are looking for?
② <u>What</u> people say about you is not important.
③ A few people seem to understand <u>what</u> makes life meaningful.
④ The puppy <u>what</u> was only two months old was separated from its mother.
⑤ He doesn't want to remember <u>what</u> happened in the car crash.

Point 03

서술형 ▶

● 밑줄 친 우리말과 뜻이 같도록 괄호 안에 주어진 단어를 이용하여 문장을 완성하세요.
(단, 관계대명사를 쓸 것)

A: Happy birthday, Amy. This bag is for you.
B: Thank you! <u>이건 제가 갖고 싶어 했던 바로 그것이에요.</u> (want, have)

→ This is exactly _____ _____ _____ _____
_____.

Unit 27 관계부사

관계부사는 「접속사+부사(구)」 역할을 하며 선행사에 따라 when, where, why, how가 쓰여요.

A 관계부사의 역할

관계부사 = 접속사 + 부사(구)

관계부사는 두 문장을 연결하며 이것이 이끄는 절 안에서 시간, 장소, 이유, 방향 등을 의미하는 부사(구)를 대신하므로 관계부사라고 부릅니다.

I remember *the place*. + I first met you **at that place**.

(→ I remember *the place* + **at that place** I first met you.)

→ I remember *the place* **where** I first met you.

　　　　　　선행사　　　　　　　　　　관계부사절

> **More** 관계부사 = 전치사+관계대명사
>
> • 관계부사는 「전치사+관계대명사」로 바꿔 쓸 수 있어요.
>
> 　I remember the place **where** I first met you.
>
> 　= I remember the place **at which** I first met you.
>
> • 관계부사는 「전치사+관계대명사」와 같은 역할을 하므로 관계부사 앞에 전치사를 중복해서 쓸 수 없어요.
>
> 　I remember the place *at* **where** I first met you. (×)

B when, where, why

❶ 시간을 나타내는 선행사+when

the time, the day, the year, the season 등 '시간'을 나타내는 선행사 뒤에 관계부사 when을 써요.

　◆ Let me know *the time* **when** she will arrive here.　　= at which

　　(← Let me know the time. + She will arrive here *at that time*.)

❷ 장소를 나타내는 선행사+where

the place, the town, the house, the spot 등 '장소'를 나타내는 선행사 뒤에 관계부사 where를 써요.

　◆ That's *the house* **where** I was born.　　= in which

　　(← That's the house. + I was born *in the house*.)

❸ 이유를 나타내는 선행사+why

이유를 나타내는 선행사 the reason 뒤에 관계부사 why를 써요.

　◆ There is *no reason* **why** it should be so expensive.　　= for which

　　(← There is no reason. + It should be so expensive *for that reason*.)

C 관계부사의 생략

❶ 선행사의 생략

선행사가 the time, the place, the reason처럼 일반적인 것일 때, 관계부사 when, where, why 자체에 그 뜻이 포함될 수 있어요.

- Now is **when** he wants to speak to you. = the time when
- This is **where** my grandfather's house used to be. = the place where
- He's quite rude. That's **why** I can't get along with him. = the reason why

❷ 관계부사의 생략

선행사를 남기고 관계부사를 생략한 채 쓰는 경우도 많아요.

- Spring is **the time** you want to be outdoors. = the time when
- This is **the place** they got married. = the place where
- Tell me **the reason** he was absent from school. = the reason why

D how

how 또는 the way 둘 중 하나만 가능

how는 선행사 없이 쓰는 관계부사이므로 the way how로는 쓰지 않아요. 선행사나 how 둘 중 하나를 생략하거나, the way that, the way in which 형태로도 쓸 수 있답니다.

- This is **how** I trained my dog.
 = This is **the way** I trained my dog.
 = This is **the way that** I trained my dog.
 = the way in which

E 관계대명사 vs. 관계부사

❶ 관계대명사 + 불완전한 구조

관계대명사는 이것이 이끄는 절에서 주어나 목적어, 보어의 역할을 하므로 관계대명사를 제외하면 절의 의미가 불완전해요.

- I know a girl **who** has iguanas as pets. has의 주어가 없음
 (주어 역할) 동사+목적어+수식어
- The museum **which** we visited in London was huge. visited의 목적어가 없음
 (목적어 역할) 주어+동사+부사구

❷ 관계부사 + 완전한 구조

관계부사는 관계부사절에서 부사(구) 역할을 하기 때문에 제외해도 절의 의미가 완전해요.

- This is the spot **where** I found your bag. 완전한 SVO절
 (부사 역할) 주어+동사+목적어

> **More** 선행사의 종류만 보고 판단할 수 없는 관계사 구별
> 선행사가 시간, 장소, 이유를 나타내더라도 불완전한 구조의 절을 이끌면 관계대명사를 써야 해요.
> September is *the month* **when** I was born.
> September is *the month* **which** I like best.

PRACTICE

STEP
1

〈보기〉에서 알맞은 관계부사를 이용하여 주어진 두 문장을 한 문장으로 바꿔 쓰세요.

〈보기〉	when	where	why	how

1 It is a famous place. Tourists go there to try Thai food.

→ It is a famous place _____ .

2 Tina told me about the way. I can find old friends through Facebook in that way.

→ Tina told me about _____ .

3 I want to know the reasons. Some dogs fear their owners for the reasons.

→ I want to know the reasons _____ .

4 The movie describes a fictional time. Robots rule the world in that time.

→ The movie describes a fictional time _____ .

5 This cafe is a popular spot. Many people come to drink coffee here.

→ This cafe is a popular spot _____ .

STEP
2

다음 괄호 안에서 어법에 맞는 것을 고르세요.

1 This is the house [where / which] the last king's family lived in.

2 He wrote a book about [how / which] he managed his money so well.

3 I don't know [why / which] time goes so slowly when I feel sleepy.

4 There was a time [when / which] there was only one continent on Earth.

*continent: 대륙

5 Today we'll study the way [how / that] airplanes work.

6 Tell me the reason [why / which] they didn't have lunch.

7 Mongolia is the country [where / which] I want to take a trip to this summer.

8 We will visit a farm [where / which] we can pick some fruits and vegetables.

STEP 3

〈보기〉에서 알맞은 관계부사를 골라 빈칸에 쓰세요.

〈보기〉	when	where	why	how

1 Do you know the reason _____ she cried last night?

2 I remember the day _____ we first met.

3 This is the place _____ the farmer's crops are stored.

4 We dream about a world _____ all people share equally in rights.

5 This Saturday is the day _____ he will be less busy.

6 He told me _____ he removed coffee stains from his shirt. In that way, I could easily remove mine.
*stain: 얼룩

7 Nobody told me the reason _____ she left me.

8 The Internet has changed _____ we watch TV. Many people prefer watching TV programs on their phones or tablets.

9 The government examined the factory _____ the spoiled food was made.
*spoiled: 상한

10 Suji made a speech about _____ she decided to do volunteer work in Laos. It was because she wanted to help children in Laos.

STEP 4

밑줄 친 부분이 어법상 맞으면 〇표, 틀리면 ✕표하고 바르게 고치세요.

1 Many tourists visit the market where is the oldest in this city.

2 That was the moment I fell in love with her.

3 The room which you have booked is where Ernest Hemingway stayed once.

4 Yesterday was the day when we will never forget.

5 This is the way how he could get the job.

6 March is the month which spring comes.

PRACTICE

정답 및 해설 p.5

STEP 5

다음 물음에 답하세요.

1 다음 중 어법상 <u>틀린</u> 문장은?

① The gift shop is the place where you can find unique greeting cards.

② I recommend the restaurant where I had dinner in Busan.

③ The movie covers the time when humans started using stone tools.

④ She told me the way how she lost weight in a short time.

⑤ Give me the information on where you got free gifts.

2 다음 중 어법과 문맥상 맞는 문장은?

① June is the month when comes before July.

② The reason when she left him was his laziness.

③ We have a library to where people in wheelchairs have access.

④ Friday evening is the time when my family likes to watch TV.

⑤ My mom brought me to the university which she had studied.

3 다음 중 밑줄 친 부분을 생략할 수 <u>없는</u> 것은?

① I want to know <u>the reason</u> why she feels so happy.

② Jessica has never been to <u>the place</u> where her father works.

③ They asked him <u>how</u> he got the VIP ticket for the concert.

④ Keep the door closed during the period <u>when</u> the air conditioner is on.

⑤ This software can save you a lot of time <u>that</u> you use to create documents.

STEP 6

우리말과 뜻이 같도록 괄호 안의 단어를 배열하여 문장을 완성하세요.

1 이곳은 우리가 지난 주말에 저녁식사를 했던 음식점이다.

(had, last weekend, the restaurant, we, dinner, where)

→ This is _____.

2 Peter는 누구에게나 항상 친절하다. 나는 그게 사람들이 그를 좋아하는 이유라고 생각한다.

(him, the reason, people, why, love)

→ Peter is always kind to everyone. I think that's _____.

Unit 27

Point 01 어법상 틀린 부분 찾기
뒤에 나오는 구조가 완전한지를 본 후, 관계부사와 관계대명사가 맞게 쓰였는지 판단할 수 있어야 해요.

Point 02 두 문장을 한 문장으로 만들기
선행사에 맞게 알맞은 관계부사를 사용하여 문장을 쓸 수 있어야 해요.

Point 03 조건에 맞게 영작하기
우리말에서 선행사에 해당하는 것을 찾아 올바른 구조로 관계부사절을 쓸 수 있어야 해요.

정답 및 해설 p.5

Point 01

● **다음 중 어법상 틀린 것은?**

① This is where a big church used to be.

② Do you know the reason why she quit the job?

③ November is the month which she was born in.

④ Please tell me how you solved the problem.

⑤ Japan is the country which people drive on the left side of the road.

Point 02

서술형 ▶

● **주어진 두 문장을 관계부사를 사용하여 한 문장으로 쓰세요.**

> I'll take you to the square.
> You can watch the fireworks there.

→ _____

Point 03

서술형 ▶

● **우리말과 일치하도록 〈조건〉에 맞게 문장을 완성하세요.**

> 우리는 그들이 행사를 취소한 이유를 모른다.
>
> 〈조건〉　• 괄호 안의 단어를 사용하여 10 단어로 쓸 것
> 　　　　• 알맞은 관계부사를 사용할 것

→ _____

(know, the event, canceled, don't)

Overall Exercises 10

[1-4] 다음 빈칸에 알맞은 말을 고르세요.

1

> They finally made _____ they wanted.

① who ② that ③ which
④ when ⑤ what

2

> That's the reason _____ I haven't finished my homework yet.

① how ② why ③ what
④ when ⑤ where

3

> Chiang Mai is a city _____ tourists can find many things to do and many places to visit.

① which ② who ③ where
④ when ⑤ how

4

> That was _____ my father met my mother for the first time.

① how ② who ③ what
④ whose ⑤ whom

5 **빈칸에 What[what]이 들어갈 수 없는 것은?**

① _____ are you going to do tomorrow?
② Can you repeat _____ you just said?
③ _____ makes perfection is practice.
④ Many teens like to do _____ their favorite celebrities do.
⑤ We recently learned _____ he was once an actor.

6 **다음 중 밑줄 친 부분의 쓰임이 나머지와 다른 하나는?**

① That is exactly <u>what</u> I wanted.
② He gave her <u>what</u> he bought.
③ Is this book <u>what</u> you are looking for?
④ Tell me <u>what</u> your phone number is.
⑤ <u>What</u> we do now can change the world.

7 **다음 우리말을 영작할 때 빈칸 (A)와 (B)에 알맞은 말은?**

> 내가 이해할 수 없는 것은 그녀가 나를 떠난 이유이다.
> → _____(A)_____ I don't understand is the reason _____(B)_____ she left me.

	(A)		(B)
①	That	that
②	That	why
③	What	why
④	What	what
⑤	What	when

8 밑줄 친 What[what]의 쓰임이 주어진 문장과 같은 것은?

> What shocked us was his rude behavior.

① Don't believe what the stranger said.
② You are too young to know what love is.
③ Do you know what the weather is like today?
④ She asked me what I want for my birthday gift.
⑤ What were you doing at home?

9 빈칸에 들어갈 말이 나머지와 다른 하나는?

① She gained much weight during the period _____ she was pregnant.
② He told me the best spot _____ I could take pictures.
③ She moved to the country _____ her aunt lived.
④ Let's meet at the cafe _____ we had lunch last week.
⑤ I often go to the bookstore _____ my cousin works.

10 다음 우리말을 영어로 알맞게 옮긴 것은?

> 저 곳이 우리가 저녁을 먹었던 식당이다.

① That is the restaurant when we had dinner.
② That is the restaurant where we had dinner.
③ That is the restaurant which we had dinner.
④ That is the restaurant at where we had dinner.
⑤ That is the restaurant there we had dinner.

[11-12] 다음 중 어법상 바른 문장을 고르세요.

11 ① I like winter when snows a lot in my town.
② You can see the time the show starts on the poster.
③ You should give me the reasons for why you skipped the class.
④ She decided to leave the house where she was born there.
⑤ His niece is studying at an American university where he sometimes visits.

12 ① I read the book what she recommended.
② That I want to be is an engineer.
③ He lost the pen what he borrowed from me.
④ He was happy about what he achieved.
⑤ This is the watch what Jeff has been looking for.

13 다음 중 밑줄 친 부분을 생략할 수 없는 것은?

① A person that I don't know sent me a letter.
② He complained about how the company handled the problem.
③ There is no reason why I should finish my homework by tonight.
④ School is the place where students spend most of their time.
⑤ Can you tell me the time when the class begins?

[14-15] 빈칸에 공통으로 들어갈 말로 알맞은 것을 고르세요.

14
• _____ you need is to get some rest.
• I don't know _____ is going on here.

① That[that] ② What[what]
③ Where[where] ④ Why[why]
⑤ How[how]

15
• Chuseok is a Korean holiday _____ people celebrate the autumn harvest.
• Do you remember the year _____ you graduated from college?

① which ② where ③ why
④ when ⑤ how

16 다음 빈칸 (A)와 (B)에 들어갈 말로 알맞게 짝지어진 것은?

• ___(A)___ is more serious is that unemployment among young people is increasing.
• Ryan followed him into a room ___(B)___ there was no furniture.
*unemployment: 실업(률)

 (A) (B)
① What which
② What where
③ What how
④ That what
⑤ That why

[17-18] 다음 중 어법상 틀린 문장을 고르세요.

17 ① We can meet at the place where is convenient for both of us.
② I enjoyed the summer vacation when I stayed at my uncle's place.
③ This is the farm where we will learn how to pick grapes.
④ Do you remember the time when you first met Sarah?
⑤ I don't understand why the service was so slow.

18 ① That is the house where my family used to live.
② I want to live in the city how I can walk everywhere.
③ Tomorrow is the day Ted is going home.
④ Show me what you have in your bag.
⑤ Please let me know how you passed the test easily.

[19-20] 다음 대화를 읽고 물음에 답하세요.

A: Look over there! There are so many people in front of the bakery.
B: I wonder _____ they're waiting in line to get into the bakery. Is it famous?
A: Yes. There is a TV program where introduces good bakeries.

19 대화의 빈칸에 알맞은 관계부사를 쓰세요.
→ _____

20 밑줄 친 문장에서 어법상 틀린 곳을 찾아 바르게 고치세요.
_____ → _____

서술형 만점 Writing Exercises

1 **우리말과 뜻이 같도록 알맞은 관계사를 이용하여 괄호 안의 단어를 배열하세요.**

(1)

나는 우리가 처음 만난 때를 기억한다.
(for the first time, the time, met, we)

→ I remember _____

_____ .

(2)

그들은 내가 알고 싶어 하는 것을 나에게 말해 주지 않았다. (know, wanted, I, to)

→ They didn't tell me _____

_____ .

(3)

누군가가 집에 침입하고 있었고, 그게 개들이 짖은 이유이다. (barked, the dogs)

→ Someone was breaking into the house, and that's _____ .

(4)

부모님이 걱정하시는 것은 너의 안전이다.
(worry about, safety, your parents, your, is)

→ _____

_____ .

2 **다음 Aloha 풀장의 표지판을 보고 알맞은 관계부사를 이용하여 문장을 완성하세요.**

(1) Night is the time _____

_____ .

(2) Aloha is the pool _____

_____ at night.

3 **다음 문장에서 어법상 틀린 부분을 바르게 고쳐 문장 을 다시 쓰세요.**

(1) He does not know the reason how his dad gets angry with him.

→ _____

(2) Next Monday is the day which Sam is going back to England.

→ _____

CHAPTER

11

접속사1

| 기본 개념 & 용어 Review |

접속사 접속사는 성분이 같은 것들을 연결해주는 다리 역할을 해요.

단어 — 접속사 — 단어

구 — 접속사 — 구

절 — 접속사 — 절

접속사와 전치사는 뒤에 오는 형태가 다르니 구분해서 알아두세요.

접속사 + 주어+동사 ~

전치사 + 명사(구)

Unit 28 단어, 구, 절의 연결

접속사는 문장에서 어떤 성분들을 <u>이어주거나</u> 문장에 의미를 <u>보충하는</u> 절을 <u>덧붙여주는</u> 역할을 해요.

A 접속사의 역할

❶ 대등한 연결

접속사는 단어와 단어, 구와 구, 절과 절을 대등하게 연결할 수 있어요.

- He has visited *Vietnam, Laos* **and** *Thailand*. 단어와 단어
- The temple is *old* **but** *beautiful*. 단어와 단어
- We enjoyed *singing songs* **and** *dancing together*. 구와 구
- Did you see her *in the morning* **or** *in the afternoon*? 구와 구
- *I did my best,* **but** *I couldn't pass the exam*. 절과 절
- He turned off the light **and** (he) went to bed.

 *주어가 같으면 접속사 뒤에 오는 주어는 생략할 때가 많아요.

> **More 구의 종류**
>
> 문장에서의 역할에 따라 대표적으로 명사구, 형용사구, 부사구가 있어요.
>
> The cell phone on the table is mine.
> └─명사구(주어)─┘ └─형용사구(주어 수식)─┘
>
> I put the cell phone on the table.
> └─명사구(목적어)─┘ └─부사구(동사 수식)─┘

❷ 주절과 종속절

「주어+동사」를 포함한 절과 절이 서로 대등하게 연결되지 않고, 문장의 한 절이 다른 절의 일부가 되어 문장 내에서 하나의 품사 역할을 하는 것을 말해요. 이때, 문장에 일부가 되는 절을 종속절이라고 합니다.

- I think **that she will win**. 명사절
 주절 종속절(think의 목적어)
- I want to know **if[whether] he will join us**. 명사절
 주절 종속절(know의 목적어)
- We will leave **when he comes back**. 부사절
 주절 종속절(부사 역할)
- I know *the artist* **who painted this picture**. 형용사절
 주절 종속절(선행사 the artist 수식)

 *앞에서 배운 관계대명사도 형용사처럼 쓰이는 종속절의 한 형태예요.

B 접속부사

두 문장을 의미적으로 연결하는 접속부사

접속사는 두 절을 연결하여 하나의 문장을 만들지만, 접속부사는 '부사'로서 두 문장을 의미적으로만 연결해요.

* Ted studied very hard. **However**, he failed the test.
 문장 1 접속부사 문장 2

* Many animals can hear well. **For example**, dogs can hear much better than we can.

therefore (결과: 그러므로, 그래서 = thus)	however (대조, 역접: 그러나)
in fact (사실)	for example (예시: 예를 들어 = for instance)
besides (첨가: 게다가 = moreover, furthermore)	instead (대신에)
on the contrary (반대로)	on the other hand (다른 한편)
otherwise (그렇지 않으면)	nevertheless (양보: 그럼에도 불구하고)
likewise (유사: 이와 같이 = in this way)	in the meantime (그러는 동안)

C 혼동하기 쉬운 접속사와 전치사

❶ 접속사 vs. 전치사

접속사와 전치사의 의미가 서로 같은 것들이 있어요. 「주어 + 동사 ~」를 이끄는 접속사인지, 명사(구)가 따라오는 전치사인지 구별해서 알아두세요.

의미	접속사 + 주어 + 동사 ~	전치사 + 명사(구)
~ 때문에	**because** he was ill	**because of** his illness **due to** his illness
~ 동안에	**while** it was raining heavily	**during** the heavy rain
~에도 불구하고	**although[though]** I had a cold **even though** I had a cold	**despite** having a cold **in spite of** having a cold

❷ 접속사와 전치사로 모두 쓰이는 것

after(~ 후에), before(~ 전에), since(~ 이래로)는 전치사로도 접속사로도 쓰여요.

* N comes **after** *M* in the alphabet. 전치사
* I arrived ten minutes **after** *he had left*. 접속사

* I will return **before** *six*. 전치사
* **Before** *it rains*, I must go out to the supermarket. 접속사

* I have studied Chinese **since** *2018*. 전치사
* I have not seen her **since** *she moved to Busan*. 접속사

PRACTICE

다음 괄호 안에서 어법에 맞는 것을 고르세요.

1 [Because / Because of] her beauty, she became a movie star.

2 [Although / Despite] he was absent, the meeting was a great success.

3 This cell phone is very popular [although / despite] its high price.

4 You should make eye contact [while / during] you are having a conversation.

5 [Although / In spite of] her bad condition, she went to work yesterday.

6 [While / During] he was speaking with me, he kept glancing at the door.

7 [Although / Despite] penguins can't fly, they can jump high.

8 [Because / Because of] her kindness, people like her very much.

9 She usually does a lot of research on products before [buys / buying] something.

10 After [a sound sleep / have a sound sleep], we feel fresh and energetic.

문맥상 가장 어울리는 말을 오른쪽에서 찾아 선을 그어 연결하세요.

1 Although it rained, • • after I finish the final exams.

2 I will go to the movies • • because my printer broke again.

3 I cannot print the files • • we went on a picnic.

4 I came to work • • in spite of having a bad cold.

STEP 3

문맥상 빈칸에 가장 알맞은 접속부사를 〈보기〉에서 골라 쓰세요. (단, 한 번씩만 사용할 것)

| 〈보기〉 | however | therefore | for example | besides |

1 The singer has a beautiful voice. _____, she has a good sense of humor.

2 Nowadays, people can do lots of things with their phone. _____, they can learn something new, watch TV, and chat with friends.

3 I wanted to arrive on time. _____, I was delayed by a traffic jam.

4 Julie was born and raised in Busan. _____, she is very familiar with the area.

| 〈보기〉 | otherwise | moreover | on the contrary |

5 His new movie was boring. _____, it was so long.

6 Some people want comfort and safety in their life. Others, _____, want a dynamic life and adventure.

7 Do not add too much chili powder. _____, it will be too spicy.

| 〈보기〉 | nevertheless | thus | in fact |

8 It was very foggy. _____, we could not get a good view of the mountain.

9 Stress itself isn't harmful. _____, when managed effectively, stress can improve one's ability and creativity.

10 The game was new to him. _____, he played it well and enjoyed himself.

STEP 4

밑줄 친 부분이 어법에 맞으면 ○표, 틀리면 ✕표 하고 바르게 고치세요.

1 <u>Despite</u> I was hungry, I skipped lunch.

2 She laughed suddenly <u>because of</u> he made a joke.

3 Please don't interrupt me <u>during</u> I'm speaking.

4 His loss of appetite was <u>due to</u> a stomachache.

5 After <u>graduate</u> from college, he worked as a teacher.

6 They have been working there <u>since</u> January.

7 We understood him <u>in spite of</u> he had a strong accent.

STEP 5

우리말과 뜻이 같도록 〈보기〉에서 알맞은 말을 고른 후 괄호 안의 단어를 배열하여 문장을 완성하세요.

〈보기〉	because of	during	despite
	because	while	although

1 여름방학 동안 나는 할머니 댁에서 지낸다.
(stay, summer, grandmother's place, my, at, vacation)

→ I _____ .

2 우리가 방에서 TV를 보고 있는 동안 전화벨이 울렸다.
(TV, we, the phone, watching, rang, were)

→ _____ in the room.

3 그의 이른 성공에도 불구하고 그는 매우 겸손하고 친절했다.
(very, success, his, was, modest, early, he)

→ _____ and kind.

4 폭설 때문에 기차가 한 시간 연착되었다.
(the train, delayed, the heavy snow, was)

→ _____ for an hour.

Unit **28**

내신
적중

Point

빈칸의 앞뒤 내용이 의미적으로 어떤 관계인지 문맥을 통해 파악하세요.

Point 02 접속사와 전치사의 쓰임 구분하기

접속사 다음에는 절이 오고 전치사 다음에는 명사(구)가 오는 것에 유의하세요.

정답 및 해설 p.7

Point
01

● 다음 글의 빈칸 (A)와 (B)에 들어갈 말로 가장 적절한 것은?

> Cultures differ from region to region. ____(A)____ , south of the Sahara Desert in Africa, when they have a conversation, holding a male friend's hand is a proper expression of friendship. ____(B)____ , in Korea, men hardly ever hold hands during conversation.
>
> *region: 지역

	(A)		(B)
①	Therefore	······	Besides
②	Therefore	······	However
③	For example	······	However
④	For example	······	Therefore
⑤	In fact	······	Besides

Point
02

● 밑줄 친 부분의 쓰임이 바르지 <u>않은</u> 것은?

① She had to wait for a long time <u>since</u> there were many people in line.

② <u>Due to</u> his mistake, we have to start all over again.

③ The airline didn't make any apologies <u>after</u> the accident.

④ Electronic devices are not allowed <u>while</u> the test.

⑤ He didn't feel satisfied <u>in spite of</u> his success in business.

등위접속사

접속사 **and, but, or**는 문법적으로 대등한 것들을 연결해요.

A and, but, or

문법적으로 성격이 대등한 단어, 구, 절을 연결하는 병렬구조

◆ I took some medicine **and** went to bed.

◆ That's a good idea, **but** I don't have enough money.

◆ Which do you prefer, summer **or** winter?

첨가: 그리고

대조: 그러나, 하지만

선택: 또는

◆ I want to learn **Spanish** and **Chinese**.

◆ I **got up** and **went** to the bathroom.

◆ He likes **to play soccer** and **(to) go skiing**.

◆ Will you be free **in the afternoon** or **at night**?

◆ **He is diligent,** but **his brother is lazy**.

명사-명사

동사-동사

부정사구-부정사구

부사구-부사구

절-절

> **More** 병렬구조를 이루는 동사
> 등위접속사가 동사를 연결할 때 수일치에 주의해야 해요.
> The fruit **smells** bad but **tastes** sweet. (단수형)

B 명령문, and[or] ~

명령문, and ~ (…해라, 그러면 ~) / 명령문, or ~ (…해라, 그러지 않으면 ~)

◆ Be nice to your friends, **and** *they'll be nice to you.*

(= If you're nice to your friends, they'll ~)

◆ Exercise enough, **or** *your bones will get weak.*

(= If you don't exercise enough, your bones ~)

C 짝을 이루는 등위접속사

등위접속사와 짝을 이루는 어구가 주어일 때 동사의 수일치에 주의

both A and B	A와 B 둘 다	항상 복수 취급
either A or B	A나 B 둘 중 하나	
neither A nor B	A와 B 둘 다 아닌	
not A but B	A가 아니라 B	B에 동사 수일치
not only A but also B (= B as well as A)	A뿐만 아니라 B도	

◆ In Canada, **both** French **and** English *are* spoken.

◆ **Either** my mom or my aunt *is* coming to the school meeting.

◆ **Neither** you nor I *am* wrong.

◆ A whale is **not** a fish **but** a mammal.

◆ **Not only** the driver **but also** the passengers *were* injured in the accident.

= The passengers **as well as** the driver *were* injured in the accident.

PRACTICE

정답 및 해설 p.7

STEP
1

괄호 안에서 문맥상 가장 적절한 것을 고르세요.

1 I'll go skating [and / but] sledding during my winter break. I can't wait!

2 Give me your paper by e-mail [but / or] in person.

3 They invited me to their wedding, [but / or] I couldn't go.

4 My knee started to ache, [but / or] I didn't stop running.

5 The person who broke the vase was not Jay [but / or] Robert.

6 Memorize these words, [and / but / or] you can't pass the test.

7 Always do your best, [and / but / or] you will be a winner.

8 You can choose either chicken [and / but / or] beef for your in-flight meal.

STEP
2

괄호 안에서 어법상 알맞은 것을 고르세요.

1 Both Ben and his sister [like / likes] sweet things.

2 The hotel was awful. The beds as well as the bathroom [was / were] so dirty.

3 Neither the owner nor the workers [expect / expects] the strike to last long.

4 Not only the government but also a lot of volunteers [is / are] working to clean up beaches polluted by the oil spill.

5 Either the students or the teacher [is / are] going to make the website for their class.

6 Not the boys but Julia [is / are] the smartest in my class.

STEP 3

괄호 안에 주어진 표현을 이용하여 두 문장을 한 문장으로 바꿔 쓰세요.

1 This book isn't new. It isn't interesting, either. (neither A nor B)

→ This book _____ .

2 We should walk quickly. Otherwise, we should take the bus. (either A or B)

→ We should _____ .

3 The concert was exciting. It was heartwarming, too. (both A and B)

→ The concert _____ .

4 The most important thing in any game is not to win. It is to take part. (not A but B)

→ The most important thing in any game _____ .

5 The living room needs to be cleaned. The bedrooms need to be cleaned, too. (not only A but also B)

→ _____ to be cleaned.

STEP 4

밑줄 친 부분이 어법상 맞으면 ○표, 틀리면 ✕표 하고 바르게 고치세요.

1 Both Amy and her husband <u>is</u> from Chicago.

2 You as well as Charlie <u>was</u> on time.

3 Either you or Mark <u>has</u> to attend the meeting.

4 Some other lizards as well as the chameleon <u>changes</u> colors.

5 The boy not only did his homework but also <u>cleaning</u> his room.

Point 01 문장 전환 완성하기

짝을 이루는 등위접속사 중 무엇을 사용해야 두 문장을 한 문장으로 연결할 수 있을지 떠올려 보세요.

Point 02 주어진 표현을 이용하여 문장 전환하기

짝을 이루는 등위접속사를 사용해서 문장을 연결할 때 대등한 것끼리 연결되도록 A, B 형태에 주의하세요.

정답 및 해설 p.8

Point 01

● 두 문장을 한 문장으로 바꿀 때 빈칸 (A), (B)에 알맞은 말은?

> Excellent communication skills are necessary to succeed. A positive attitude is necessary, too.
>
> = ＿＿(A)＿＿ excellent communication skills ＿＿(B)＿＿ a positive attitude is necessary to succeed.

	(A)		(B)
①	Either	……	or
②	Both	……	and
③	Neither	……	nor
④	Not	……	but
⑤	Not only	……	but also

Point 02

서술형 ▶

● 다음 두 문장을 괄호 안에 주어진 표현을 이용하여 한 문장으로 바꿔 쓰세요.

> School violence hurts your body. Besides, it affects mental health negatively.

(1) (not only, but also)

→ School violence ＿＿＿＿＿＿＿＿＿＿＿＿＿＿＿＿

＿＿＿＿＿＿＿＿＿＿＿＿＿＿＿＿＿＿＿＿＿ .

(2) (as well as)

→ School violence ＿＿＿＿＿＿＿＿＿＿＿＿＿＿＿＿

＿＿＿＿＿＿＿＿＿＿＿＿＿＿＿＿＿＿＿＿＿ .

Overall Exercises 11

[1-4] 다음 빈칸에 가장 적절한 말을 고르세요.

1

> _____ you're far away from home, you can sign up to vote for the election.

① However ② Although
③ Despite ④ But
⑤ Neither

2

> She went to see a doctor _____ she had a terrible headache.

① but ② or
③ due to ④ therefore
⑤ because

3

> Wash your hands when you get home, _____ you may catch the flu.

① or ② and
③ instead ④ after
⑤ besides

4

> My family is planning to go to either Rome _____ Venice this summer.

① and ② but
③ also ④ or
⑤ nor

5 **밑줄 친 부분의 쓰임이 바르지 않은 것은?**

① <u>Because</u> he was absent, I was worried about him.
② Their business failed <u>despite</u> they had a big budget.
③ Set your alarm, <u>and</u> you'll not be late for school.
④ <u>While</u> she was studying, someone knocked on the door.
⑤ <u>After</u> she looked through her bag, she realized she had lost her purse.

*budget: 예산

6 **빈칸에 들어갈 말이 다른 하나는?**

① Would you prefer iced tea _____ hot coffee?
② Either you _____ Ted has to attend the class.
③ Exercise more, _____ you'll get too fat.
④ Don't tell lies, _____ people will trust you.
⑤ Are you going there by bus _____ by subway?

7 **다음 두 문장의 의미가 같을 때 빈칸에 알맞은 말은?**

> I fell asleep while I was watching the movie.
> = I fell asleep _____ the movie.

① on ② during
③ since ④ before
⑤ although

8 다음 두 문장의 의미가 같을 때 빈칸 (A), (B)에 알맞은 말은?

> My father has a car as well as a motorcycle.
> = My father has _____(A)_____ a motorcycle _____(B)_____ a car.

	(A)		(B)
①	neither	······	nor
②	either	······	or
③	not only	······	but also
④	not	······	but
⑤	with	······	and

[9-10] 빈칸에 공통으로 들어갈 말로 가장 적절한 것을 고르세요.

9
> • We've known each other _____ we were very young.
> • I haven't eaten anything _____ breakfast.

① before ② during
③ after ④ since
⑤ when

10
> • Both Jim _____ I want to be a reporter.
> • Take this medicine, _____ you will get much better.

① but ② and
③ or ④ nor
⑤ as

11 다음 우리말을 영어로 알맞게 옮긴 것은?

> 그 수업은 재미있을 뿐만 아니라 도움도 된다.

① The class is not fun but helpful.
② The class is either fun or helpful.
③ The class is not only fun but also help.
④ The class is not only fun and also helpful.
⑤ The class is not only fun but also helpful.

[12-13] 다음 중 어법상 바른 문장을 고르세요.

12
① Yesterday, it not only rained but also snow.
② He practiced dancing and to sing for the school festival.
③ I'm neither upset nor angry about the decision.
④ Both the boy and his parents looks happy.
⑤ She is allergic to fur but raise a cat.

13
① You should think twice before speak.
② No one had interest in the band. Nevertheless, they kept singing in the street.
③ Although his financial difficulties, he helps poor people.
④ After complete this form, return it to me.
⑤ They either work or gets some rest after five o'clock.

[14-15] 다음 빈칸에 들어갈 말이 순서대로 바르게 짝지어진 것을 고르세요.

14

> The driver got arrested _____ he drove a car without a driver's license. _____, he drank a lot of alcohol right before driving.

① because ⋯⋯ Besides
② because ⋯⋯ Therefore
③ because of ⋯⋯ Moreover
④ because of ⋯⋯ Otherwise
⑤ therefore ⋯⋯ In fact

15

> _____ Ben and his neighbor got angry at the journalist's careless article. _____, the newspaper had to apologize to them.

① Either ⋯⋯ However
② Both ⋯⋯ However
③ Both ⋯⋯ Therefore
④ Not only ⋯⋯ Therefore
⑤ Neither ⋯⋯ Besides

16 **밑줄 친 부분 중 어법상 틀린 것은?**

> From the 5th to the 15th century, Europeans ① with dental problems visited men ② called barber surgeons. They ③ performed many services ④ like cutting hair, pulling teeth, and ⑤ to treat medical conditions.
>
> *surgeon: 외과 의사

[17-18] 다음 중 어법상 틀린 문장을 고르세요.

17
① Both you and I were responsible for it.
② I'll meet him either today or tomorrow.
③ I helped not only Bill but also his sister.
④ The light went out while I was watching TV.
⑤ My parents as well as my sister needs regular exercise.

18
① At school, we gain social skills as well as knowledge.
② This resort has both tennis courts and swimming pools.
③ The election will be held either in September or in October.
④ Put on your hat on the beach, and you will get sunburned.
⑤ Be polite to others, and they will do the same for you.

[19-20] 다음 문장에서 어법상 틀린 곳을 찾아 바르게 고치세요.

19

> He goes to work by bicycle because the rush hour traffic.

_____ → _____

20

> It can be very exciting to move to another country and experiencing another way of life.

_____ → _____

서술형 만점 Writing Exercises

1 다음 우리말과 같은 뜻이 되도록 괄호 안의 단어와 알맞은 접속사를 이용하여 문장을 완성하세요.

(1)
> 나는 Kate나 Leo 둘 중 한 명을 파티에 데려 갈 거야. (either, take, to the party)

→ I'm going to _____

_____ .

(2)
> 그 남자아이들이 아니라 내 친구 수진이가 조종사가 되고 싶어 한다.
> (want, my friend Sujin, the boys, to become, not)

→ _____

_____ a pilot.

(3)
> 나에게 사실을 말해라, 그러면 나는 너를 용서할 것이다. (will, tell, forgive, the truth)

→ _____

(4)
> 우리는 크리스마스이브에 음식을 만들었을 뿐만 아니라 선물도 준비했다.
> (food, gifts, not only, prepare, make)

→ _____

_____ on Christmas Eve.

2 Amy와 부모님의 모습이 담긴 사진을 보고 괄호 안의 단어를 이용하여 문장을 완성하세요.
(단, 현재진행형으로 쓸 것)

(have, fun)

→ _____ Amy _____ her parents

_____ _____ _____ at the

amusement park.

3 두 개의 상자에서 서로 어울리는 문장을 찾아 however 또는 therefore로 연결하세요.

> (1) He's a strict vegetarian.
> (2) Eric did not study hard for the test.
> (3) Jim is only fifteen.

> • He failed.
> • He can't drive a car.
> • He doesn't blame people who eat meat.

(1) _____

(2) _____

(3) _____

CHAPTER

12

접속사 2

| 기본 개념 & 용어 Review |

부사절 접속사 때, 이유, 조건 등 부사의 성격을 가진 절을 이끌며, 부사절은 생략해도 문장이
성립해요.

주절 + 부사절

완전한 절 + 완전한 절

명사절 접속사 문장에서 주어, 목적어, 보어와 같이 명사 역할을 하는 절을 이끌므로 생략할 수
없어요.

주절 + 명사절

불완전한 절 + 완전한 절

접속사를 사용해서 누군가가 한 말을 그 말을 전달하는 사람의 입장에서 바꿔 말할 수 있어요. 이를
간접화법 이라고 해요.

직접화법 ~가 말하다, "~~~".

간접화법 ~가 …라고 말하다.

Unit 30 부사절을 이끄는 접속사

접속사가 때, 이유, 조건, 양보, 목적 등을 나타내는 부사절을 이끌기도 해요.

A 때를 나타내는 접속사

when, as, while, after, before, until[till], since 등

* **When[As]** he was twenty, he moved to Paris. ~할 때
* **While** I was having dinner, I watched TV. ~하는 동안
* **After** he finished his homework, he went to bed. ~한 이후에
* He washed his face **before** he went to bed. ~하기 전에
* We waved **until[till]** the car was out of sight. ~할 때까지
* I have studied English **since** I was in kindergarten. ~한 이래로
* We will start the meeting **once** everyone arrives. 일단[한번] ~하면
* **Every time** I looked at him, he was looking at me. ~할 때마다
* **As soon as** she came home, she began to study. ~하자마자

B 이유를 나타 내는 접속사

because, as, since: ~하기 때문에

* I didn't buy the bag **because** it was too expensive.
 cf. **Because of** the typhoon, they had to cancel their trip. 전치사: ~ 때문에
* **As** I was tired, I fell asleep very quickly.
* You should ask Mr. Kim **since** he is an expert in computers.

C 조건을 나타 내는 접속사

if, unless, as long as

* **If** it rains tomorrow, I will not go out. ~한다면
* **Unless** you're too tired, let's have dinner out. ~하지 않는다면
 (= **If** you're **not** too tired, let's ...)
* He will fight **as long as** he is alive. ~하는 한

> **More** 명사절과 부사절의 시제
> 명사절에서는 미래를 나타낼 때 미래 시제를 쓰지만, 시간과 조건의 부사절에서는 _____ 시제로 미래를 나타 내요.
> **When** they **arrive**, I will give them some snacks. (부사절: ~할 때)
> **If** you **don't study** harder, you won't pass the test. (부사절: 만약 ~한다면)
> cf. Let me know **if** you **will be** able to attend. (명사절: ~인지 아닌지)

D 양보를 나타내는 접속사

although, though, even though: 비록 ~일지라도, ~에도 불구하고

- **Although** the dog is big, he's very cute.
- My parents scolded me **though** it was not my fault.
- She wants more money **even though** she is rich.

E 목적, 결과를 나타내는 접속사

❶ so (that) ~ can[may]: ~하기 위해

- You should do your best <u>**so (that)** you **can[may]** get to the top.</u>
 목적

 = You should do your best **in order that** you **can[may]** get to the top.

❷ so 형용사[부사] ~ that ...: 너무[매우] ~해서 …하다

- The train was **so** crowded <u>**that** I could hardly move.</u>
 결과
- The weather is **so** nice **that** we will go cycling.

F 다양한 의미를 지닌 접속사

❶ while

- Please look after my plants **while** I'm away. ~하는 동안
- Some people waste food, **while** others don't have enough.

 ~하는 반면에

❷ as

- A good idea occurred to me **as** I was taking a shower. ~할 때, ~하면서
- **As** my TV wasn't working, I missed the program. ~하기 때문에
- **As** he grew older, he became generous. ~함에 따라, ~할수록
- Do **as** you were told. ~하는 대로

> **More** 전치사로도 쓰이는 as
>
> He acted **as** <u>chairman</u>. (~로서(자격))
> 명사
> It can be used **as** <u>a knife</u>, too. (~로써(수단, 도구))
> 명사

❸ since

- He has made big changes **since** he quit his job. ~한 이래로
 cf. I've not heard from him **since** last fall. 전치사: ~ 이후에
- I'm forever on a diet **since** I put on weight easily. ~하기 때문에

PRACTICE

빈칸에 가장 알맞은 접속사를 〈보기〉에서 골라 쓰세요. (단, 한 번씩만 사용할 것)

| 〈보기〉 | because | once | so that | before | unless |

1 Please speak louder ＿＿＿＿＿＿ everyone can hear you.

2 I can't contact her ＿＿＿＿＿＿ I don't have her phone number or e-mail address.

3 I recommend low-fat milk. ＿＿＿＿＿＿ you get used to it, you will find whole milk too thick to drink.

4 ＿＿＿＿＿＿ you go out for lunch, you have to finish your homework first.

5 ＿＿＿＿＿＿ the owner hires more workers, he cannot open a new store.

| 〈보기〉 | until | every time | if | though | as soon as | as long as |

6 I love soccer and I want to keep playing ＿＿＿＿＿＿ I can.

7 ＿＿＿＿＿＿ the unknown singer finished his song, we stayed in our seats.

8 ＿＿＿＿＿＿ she entered her room, she knew there was something wrong.

9 ＿＿＿＿＿＿ he talks to others, he shows off about how rich he is.

*show off: 자랑하다

10 She immediately recognized me ＿＿＿＿＿＿ she hadn't seen me for years.

11 ＿＿＿＿＿＿ you are interested in art, the exhibition being held now at this gallery would be great.

STEP 2 밑줄 친 부분의 뜻으로 알맞은 것을 〈보기〉에서 골라 그 기호를 쓰세요.

〈보기〉 ⓐ ~하는 동안 ⓑ ~하는 반면에

1 Some books teach important life lessons, <u>while</u> others do not.

2 <u>While</u> Joe prefers to rest at home, his brother likes to hang out with his friends.

3 We prepared a surprise party for Kate <u>while</u> she was studying at the library.

〈보기〉 ⓐ ~하기 때문에 ⓑ ~한 이래로

4 We have been good friends <u>since</u> we were 5 years old.

5 <u>Since</u> we have a little time before boarding the train, let's have a cup of coffee.

〈보기〉 ⓐ ~하는 대로 ⓑ ~할 때, ~하면서 ⓒ ~하기 때문에
ⓓ ~함에 따라, ~할수록 ⓔ ~로서

6 Where is the guard? I couldn't see him <u>as</u> I was coming into the building.

7 They could not buy a house <u>as</u> they hadn't saved enough money.

8 <u>As</u> Jason grew up, he became more interested in music.

9 <u>As</u> I said on the phone, I am extremely pleased with the job.

10 What's the best part of having a daughter <u>as</u> a father?

PRACTICE

정답 및 해설 p.9

STEP 3

밑줄 친 접속사의 뜻이 주어진 문장과 같은 것을 고르세요.

1

> As the coach said, attack is the best method of defense.

① Our picnic was canceled as it was snowing.
② As she gets older, she is becoming more confident.
③ I must leave now as I have so much work to do.
④ As the plane took off, I was watching from the window.
⑤ As I told you yesterday, the company is having financial difficulties.

2

> While we arrived ten minutes early, the others didn't arrive on time.

① While you chop the vegetables, I will make fried eggs.
② My dad always listens to the radio while he drives.
③ While I was sleeping, my dog ate all the cheese.
④ The doorbell rang while I was sweeping the floor.
⑤ The eastern part of Istanbul is in Asia, while the western part is in Europe.

STEP 4

우리말과 뜻이 같도록 〈보기〉에서 알맞은 접속사를 고른 후 괄호 안의 단어를 배열하여 문장을 완성하세요.

〈보기〉 as soon as so ~ that although

1 비록 그 일이 너에게 어려울지라도 열심히 연습하면 잘 할 수 있다.
(is, for, the task, difficult, you)

→ _____, you can do well if you

practice hard.

2 그녀는 책을 펴자마자 잠이 들었다. (she, asleep, a book, fell, opened)

→ She _____.

3 Paul은 너무 아파서 오늘 학교에 가지 못했다.
(couldn't, was, go to school, Paul, sick, he)

→ _____ today.

68 Chapter 12 **접속사 2**

Unit 30

Point 01. 빈칸에 공통으로 들어갈 말 찾기
문맥에 따라 다양한 의미를 갖는 접속사를 잘 알아두세요.

Point 02 같은 뜻이 되도록 문장 다시 쓰기
문장의 뜻을 파악한 뒤 알맞은 의미의 접속사를 쓸 수 있어야 해요.

Point 03 어법상 틀린 곳 고치기
접속사의 의미를 바르게 알고 문장에서 어떻게 쓰이는지 주의하세요.

정답 및 해설 p.9

Point 01

다음 빈칸에 공통으로 들어갈 말로 알맞은 것은?

> • _____ we go up, the air grows colder.
> • I couldn't go into the room _____ the door was locked.

① [As]as ② [If]if ③ [Since]since
④ [Though]though ⑤ [While]while

Point 02

서술형 ▶

주어진 문장과 같은 뜻이 되도록 알맞은 접속사를 사용하여 문장을 다시 쓰세요.

> In spite of the bad weather, there were many baseball fans at the stadium.

→ _____, there were many baseball fans at the stadium.

Point 03

서술형 ▶

우리말과 뜻이 같도록 쓸 때 다음 문장에서 어법상 틀린 곳을 찾아 고치세요.

> 비상사태가 아니라면 빨간색 단추를 누르지 마시오.
> → Do not push the red button unless it is not an emergency.

_____ → _____

Unit
31

명사절을 이끄는 접속사

접속사가 이끄는 명사절은 문장에서 주어, 목적어, 보어 역할을 해요.

A 명사절을 이끄는 접속사

❶ that + 주어 + 동사: ~하다는 것

접속사 that이 이끄는 절이 주어 역할을 할 때는 주로 가주어 <u>1 </u> 을 대신 쓰고 문장 뒤로 보냅니다. that이 목적어절을 이끌 때는 생략되는 경우가 많아요.

* **That** he is rich is true.
 → It is true **that** he is rich.
* She said (**that**) she would visit Seoul this spring.
* His problem is **that** he is never satisfied.

> 주어: ~하다는 것은
> 가주어 it ~ 진주어 that절
> 목적어: ~하다는 것을
> 보어: ~하다는 것이다

❷ if, whether + 주어 + 동사: ~인지 (아닌지)

if가 명사절을 이끌 때는 whether(~인지 (아닌지))와 같은 의미로 쓰여요. 단, if는 주어가 되는 명사절을 이끌 수 없으며, 주로 타동사의 목적어절을 이끌어요.

* **Whether** he will visit her is not certain.
* I wonder **if**[**whether**] it's going to rain tonight.
* The question is **whether** we have enough time.

> 주어
> 목적어
> 보어

B 주절-종속절 시제 일치

접속사 that이 이끄는 명사절을 종속절이라 하는데, 주절의 시제에 따라 종속절의 시제가 달라져요.

❶ 주절이 현재, 현재완료, 미래 → 종속절은 모든 시제 가능

He	says has said will say	(that)	he studies hard.
			he has studied hard.
			he studied hard.
			he will study hard.

❷ 주절이 과거 → 종속절은 과거나 과거완료

* I *knew* that he **was** busy.
* I *heard* that Sam **had been** ill.

❸ 시제 일치의 예외

종속절이 진리, 격언, 현재의 습관 등을 나타낼 때는 주절의 시제와 관계없이 종속절을 항상 <u>2 </u> 시제로 써요. 단, 역사적 사실을 나타낼 때는 반드시 <u>3 </u> 시제로 씁니다.

* We *learned* that oil **floats** on water.
* My father always *said* that time **is** money.
* He *told* me that he **gets** up at seven every morning.
* They *don't know* that King Sejong **invented** Hangul.

> 일반적 진리: 현재시제
> 격언: 현재시제
> 현재의 습관: 현재시제
> 역사적 사실: 과거시제

C 화법전환

❶ 직접화법과 간접화법

다른 사람의 말을 그대로 전달하여 말하는 방식이 직접화법이고, 전달자의 입장으로 바꾸어 말하는 방식이
간접화법이에요.

* Peter said, "**I will help you.**" 직접화법
* Peter said that **he would help me**. 간접화법

❷ 평서문의 간접화법

say[said] → 그대로 씀 / say[said] to → tell[told]	
콤마(,)와 인용부호(" ") → 삭제하고 접속사 that으로 연결	
that절의 주어나 목적어 등은 주절의 주어를 기준으로 알맞은 인칭대명사로 바꿈	
that절의 동사는 주절의 시제에 맞춰 시제 일치	
부사·지시대명사는 다음과 같이 바꿈	
today → that day	yesterday → the day before, the previous day
tomorrow → the next[following] day	now → then ago → before
this[these] → that[those]	here → there

* My brother said to me, "I will give you my book tomorrow."
 → My brother **told** me (**that**) **he would** give **me his** book **the next day**.

❸ 의문사가 있는 의문문의 간접화법

이 때에도 전달자의 입장에 맞게 인칭과 시제 등을 바꿔 써야 해요. 특히 어순에 유의합니다.

* He asked, "**What** are you doing?"
 → He **asked what I was** doing. ask + 의문사 + 주어 + 동사

D 간접의문문

의문사가 이끄는 절의 어순 = 의문사 + 주어 + 동사

의문사가 절을 이끌어 문장의 일부가 된 것을 간접의문문이라고 해요. 이때 간접의문문의 어순에 주의하세요.

* Can you explain? + **What is that**? → Can you explain **what that is**?
 동사+주어 의문사+주어+동사

* Tell me **who said that**.
 의문사(주어)+동사

*의문사가 주어일 때는 의문사 바로 뒤에 동사를 써서 간접의문문을 만들어요.

┌───┐
More 의문사+do you think+주어+동사

주절의 동사가 think, believe, guess, suppose, imagine 등 상대방의 견해를 묻는 말일 때는
「의문사+do you think[believe, …]+**4**_____+**5**_____」의 어순으로 써요.

Do you think? + **What this is**?
→ **What** do you think **this is**? (상대방의 생각을 물음)

cf. 알고 있는지 아닌지 여부(Yes/No)를 물을 때는 「의문사+주어+동사」의 어순을 따름

Do you know **what this is**? (알고 있는지 아닌지를 물음)
└───┘

PRACTICE

빈칸에 가장 알맞은 것을 <보기>에서 골라 쓰세요.

<보기>	that	if[whether]

1 I couldn't believe _____ Hassan has four brothers.

2 The company will decide _____ it will remain here or move to a larger space.

3 The problem is _____ we have nothing to replace oil at the moment.

4 It's my belief _____ people are born with the potential to be creative.

5 I wonder _____ the rumor is true.

6 He told me _____ he goes to bed at eleven every night.

7 Tom asked me _____ I could go to the movies this weekend.

괄호 안에서 어법에 맞는 것을 고르세요.

1 We hoped the government [won't / wouldn't] raise taxes again.

2 My mother always said that practice [makes / made] perfect.

3 Until the 1800s, most Americans thought that tomatoes [are / were] poisonous.

*poisonous: 독이 있는

4 The police thought that the fire [have started / had started] due to electrical problems.

5 Ms. Carter taught that the First World War [broke out / had broken out] in 1914.

6 The children learned that the river [flows / would flow] to the ocean.

STEP 3

다음을 간접화법으로 바꿔 문장을 완성하세요.

1 The boy said to her, "I will help you."

→ The boy told her that _____.

2 Sarah said to her sister, "I have never seen such a thing."

→ Sarah told her sister that _____.

3 Ben asked me, "Why do you look so happy?"

→ Ben asked me _____.

4 He said to her, "I was at the library an hour ago."

→ He told her that _____.

5 I asked him, "What will you do tomorrow with your friends?"

→ I asked him _____.

6 They said, "We danced all night yesterday."

→ They said that _____.

STEP 4

굵은 글씨로 된 의문문을 간접의문문으로 바꾸어 두 문장을 한 문장으로 바꿔 쓰세요.

1 Can you tell me? + **What do you want?**

→ _____

2 I wonder. + **Which company did Ben work for?**

→ _____

3 I need to find out. + **When is he going to leave?**

→ _____

4 Do you know? + **Where does she want to visit?**

→ _____

5 Do you think? + **What is true friendship?**

→ _____

6 Do you guess? + **Who should I trust?**

→ _____

PRACTICE

STEP

5

우리말과 뜻이 같도록 괄호 안의 단어를 이용하여 문장을 완성하세요.

1 Joan은 다시는 학교에 늦지 않겠다고 말했다.

(be late, will, for school, again, she, not)

→ Joan said _____.

2 그녀는 나에게 자신의 집에 들를 수 있는지 물었다.

(me, drop by, can, her house, I)

→ She asked _____.

3 그는 운전기사에게 다음 버스가 언제 도착하는지 물었다.

(arrive, the driver, the next bus, will, when)

→ He asked _____.

4 그녀는 자신이 매일 아침 자전거를 탄다고 말했다.

(ride, every morning, she, her bike)

→ She said that _____.

5 그가 시험에서 부정행위를 했던 것은 사실이다.

(cheat, true, he, on the test, is)

→ It _____.

6 문제는 비행기가 제시간에 출발할 수 있는지이다.

(can, on time, the plane, depart)

→ The problem is _____.

7 너는 누가 Karen을 좋아하는지 아니? (who, know, likes)

→ _____

Point 01 밑줄 친 부분의 쓰임이 다른 것 찾기

형용사 역할을 하는 관계대명사절과 달리 접속사 that이 이끄는 명사절은 문장에서 명사 역할을 해요.

Point 02 문장 전환하기

직접화법을 간접화법으로 바꿀 때는 두 화법 간에 시제, 대명사, 부사 등이 달라지는 것에 유의하세요.

정답 및 해설 p.10

Point 01

● 다음 주어진 문장의 밑줄 친 부분과 쓰임이 <u>다른</u> 것은?

> I think <u>that</u> he did the right thing.

① I didn't know <u>that</u> it was you.
② It is surprising <u>that</u> he became a lawyer.
③ She is the only person <u>that</u> I can depend on.
④ The truth is <u>that</u> they haven't solved the problem.
⑤ She apologized <u>that</u> she made a wrong decision.

Point 02

● 다음 중 화법 전환이 <u>잘못된</u> 것은?

① She said to me, "I will stay home."
 → She told me that she would stay home.
② I asked them, "Where do you study after school?"
 → I asked them where they studied after school.
③ He asked, "What are you doing here?"
 → He asked what I was doing there.
④ Bob said to him, "I can't do this work now."
 → Bob told him that he couldn't do that work then.
⑤ Eric said to me, "I met your sister yesterday."
 → Eric told me that he had met your sister the day before.

Overall Exercises 12

[1-4] 다음 빈칸에 가장 적절한 말을 고르세요.

1
> She turned all the lights off _____ she could sleep well.

① if ② after
③ so that ④ as long as
⑤ every time

2
> Everyone in the audience was deeply moved _____ the opera was over.

① while ② since
③ because ④ if
⑤ after

3
> _____ you may know, pandas are in danger of extinction.
>
> *extinction: 멸종

① As ② Because
③ When ④ Although
⑤ If

4
> I didn't know _____ they really enjoyed the show.

① what ② whether
③ unless ④ who
⑤ as soon as

[5-7] 주어진 문장의 밑줄 친 부분과 쓰임이 같은 것을 고르세요.

5
> If you do not run now, you will miss the bus.

① The party will be held inside if it rains.
② It doesn't matter if we go or stay.
③ The doctor asked me if I felt okay.
④ Please ask her if she wants some milk.
⑤ Do you know if they left the office?

6
> He has written a letter only once since he moved.

① I was late since my car broke down.
② Since I live near the sea, I enjoy fishing.
③ Since I graduated from high school, I've lived by myself.
④ Since she is ill, I can't take her with me.
⑤ Since there was no water, I couldn't take a shower.

7
> Jerry passed the exam on his first attempt, while I had to take it again.

① Tim arrived while we were playing soccer.
② Some apples are still green, while others are red.
③ Keep the stove upright while it is turned on.
④ You must not cross the street while the light is red.
⑤ While he made a speech, we kept silent.

8 다음 두 문장을 한 문장으로 바르게 바꾼 것은?

① Can you explain? + Why was he crying?
→ Can you explain why he crying was?
② I can't remember. + Who called me?
→ I can't remember who I called.
③ I don't care. + What do people think about me?
→ I don't care what do people think about me.
④ Do you know? + Who are the boys?
→ Who do you know the boys are?
⑤ Could you tell me? + What is your new address?
→ Could you tell me what your new address is?

9 밑줄 친 that 중 쓰임이 다른 하나는?

① It is not surprising that the team lost the game again.
② Harry promised that he would give me a call today.
③ He doubts that the movie is based on a true story.
④ I know some stories that will make you laugh.
⑤ The good news is that Grace is feeling better now.

10 다음 문장에서 어법상 틀린 곳을 찾아 고치세요.

My grandmother wants to know when will I visit her.

_____ → _____

[11-12] 빈칸에 공통으로 들어가기에 알맞은 말을 고르세요.

11

• _____ Jack is injured, the team needs another player.
• She smiled _____ she waved goodbye to me.

① As[as] ② Because[because]
③ Whether[whether] ④ Since[since]
⑤ If[if]

12

• Some whales stand on their tails _____ they sleep.
• Some books are very interesting, _____ others are not.

① because ② since
③ while ④ though
⑤ before

13 다음 두 문장을 한 문장으로 바르게 바꿔 쓴 것은?

Do you think? + Who will win the competition?

① Do you think who will win the competition?
② Do you think will who win the competition?
③ Who you think will win the competition?
④ Who will you think win the competition?
⑤ Who do you think will win the competition?

14 밑줄 친 부분이 어법상 틀린 것은?

① Though the guitar is cheap, its sound is great.
② I can't tell if he was satisfied with the result.
③ Can you tell me what is it?
④ As soon as he got the message, he replied to it.
⑤ Please wait here until the table is ready.

15 다음 문장을 간접화법으로 바르게 전환한 것은?

> My sister said to me, "I have a math class today."

① My sister told me that I have a math class that day.
② My sister told me that I had a math class that day.
③ My sister told me that she has a math class that day.
④ My sister told me that she had a math class today.
⑤ My sister told me that she had a math class that day.

[16-17] 다음 중 어법상 틀린 문장을 고르세요.

16 ① Unless you are busy, I want you to help me with my work.
② Though she is young, she is brilliant enough to teach others.
③ There will be no problem as long as you keep the documents.
④ She asked me why didn't I answer the phone.
⑤ The knife was so sharp that I had to be more careful.

17 ① I didn't know you and Jane were sisters.
② Do you know how this machine works?
③ While I was doing my homework, I listened to the radio.
④ Whether she will join us is not certain.
⑤ I thought that I will be a model someday.

[18-19] 다음 글을 읽고 물음에 답하세요.

> Wilma got polio ____(A)____ she was four years old, so she couldn't walk. ⓐ Although she was ill, she didn't give up hope. She tried hard ⓑ so that she could walk again. ⓒ Because her strong will, Wilma was finally able to walk. ____(B)____ she practiced walking faster, she found a love for running. She was not sure ⓓ if she could run in a race, but she didn't stop. At last, she succeeded ⓔ as an athlete.
>
> *polio: 소아마비 **athlete: 육상선수

18 문맥상 윗글의 빈칸 (A)와 (B)에 들어갈 말이 바르게 짝지어진 것은?

	(A)		(B)
①	while	Before
②	when	While
③	until	Every time
④	whether	Though
⑤	since	Unless

19 윗글의 밑줄 친 ⓐ~ⓔ 중 어법과 문맥상 알맞지 않은 것은?

① ⓐ ② ⓑ ③ ⓒ
④ ⓓ ⑤ ⓔ

Writing Exercises

1 우리말과 같은 뜻이 되도록 괄호 안의 단어와 알맞은 접속사를 이용하여 문장을 완성하세요.

(1)
> 모든 사람이 그녀가 결백하다는 것을 안다.
> (knows, innocent, everybody)

→ _____ .

(2)
> 그들이 오늘 도착할지는 확실하지 않다.
> (arrive, will, today)

→ _____

 is not certain.

2 주어진 두 문장을 〈조건〉에 맞게 한 문장으로 바꿔 쓰세요.

(1) He is not rich. He always helps poor people.

> 〈조건〉
> 접속사 if, although, since 중 하나를 사용할 것

→ _____

 poor people.

(2) Please tell me. When does she come home?

> 〈조건〉
> 간접의문문으로 쓸 것

→ _____

3 다음 그림 속 Eric이 한 말을 주어진 문장으로 다시 쓰세요.

I can't watch this scary movie alone.

→ Eric said that _____

_____ .

4 다음 대화를 읽고 물음에 답하세요.

> A: This question is so difficult. (A) 너는 답이 뭐라고 생각하니?
> B: I think the answer is number 2.
> A: (B) Why is that? Can you explain?
> B: Sure. It's very simple. Look at this first.

(1) 밑줄 친 (A)의 우리말과 뜻이 같도록 주어진 단어를 사용해서 문장을 완성하세요.

(think, be, what, the answer)

→ _____

(2) 밑줄 친 (B)의 두 문장을 간접의문문 형태의 한 문장으로 바꾸세요.

→ _____

CHAPTER

13

분사구문

| 기본 개념 & 용어 Review |

분사구문 분사구문이란 분사를 이용해 문장의 길이를 줄이거나 설명을 덧붙인 것이에요.

접속사+주어+동사, 주어+동사 ~

↓

v-ing ~/p.p. ~ , 주어+동사 ~

문맥에 따라 '동시동작, 연속동작, 시간, 이유' 등 여러 가지 의미로 해석될 수 있어요.

분사구문의 형태와 의미

분사구문은 「접속사+주어+동사」로 된 부사절을 분사가 이끄는 구의 형태로 간결하게 나타낸 것을 말해요.

A 분사구문 만드는 법

「접속사 + 주어 + 동사 ~」→「현재분사(v-ing) ~」

1 부사절의 접속사 생략	~~When~~ she arrived in Paris, she contacted him.
	_{부사절}　　　　　　　　　_{주절}

↓

2 부사절과 주절의 주어가 같으면 부사절의 주어 생략	~~She~~ arrived in Paris, she contacted him.

↓

3 부사절의 동사를 현재분사 (v-ing)로 바꿈	**Arriving** in Paris, she contacted him.
	_{분사구문(부사구)}

More 분사구문 만들 때 유의할 점

- 분사구문의 의미가 명확히 전달되도록 접속사를 생략하지 않고 남겨두기도 합니다.
 While running in a race, I hurt my knee. (← While I was running, ~.)
- 부사절과 주절의 주어가 같지 않을 때, 부사절의 주어를 그대로 남겨두어야 해요.
 It raining heavily, *the game* was canceled. (← Because it rained heavily, ~.)
- 부사절에 be동사가 쓰였을 때는 현재분사 being을 쓰며, 동사가 진행형일 때는 v-ing만 남겨요.
 When I *am* sad, I listen to lively music. → **Being** sad, I ~.
 While I *was watching* TV, I ate some snacks. → **Watching** TV, I ~.

B 분사구문의 여러 의미

❶ 동시동작 / 연속동작

while, as(~하면서, ~하는 동안에)라는 동시동작의 의미나, and, after(~하고 나서 …하다)라는 연속동작의 의미를 나타내는 경우가 많아요.

- **Smiling** brightly, Jennifer approached him.　　_{동시동작: ~하면서 …하다}
 (= **As** she smiled brightly, Jennifer approached him.)
- **Raising** his hand, he stood up.　　_{연속동작: ~하고 나서 …하다}
 (= He raised his hand, **and** stood up.)

❷ 시간

when, as(~할 때), since(~ 이후로), before, as soon as(~하자마자) 등 어떤 일이 발생한 시간을 나타내기도 합니다.

- **Seeing** the bus coming, she started to run.　　_{시간: ~할 때}
 (= **When** she saw the bus coming, she started to run.)

❸ 이유, 원인

because, as, since(~ 때문에) 등 이유나 원인을 설명해주기도 해요.

- **Having** too many things to do, I can't go out.　　_{이유, 원인: ~ 때문에}
 (= **Because** I have too many things to do, I can't go out.)

PRACTICE

STEP 1

다음 문장을 분사구문으로 바꿔 쓰세요.

1 While I was walking down the street, I met my friend.

→ _____, I met my friend.

2 The audience stood up and then burst into applause.

→ _____, the audience burst into applause.

3 As my dad played the guitar, he sang a song for my mom.

→ _____, my dad sang a song for my mom.

4 When I opened the door, I found that no one was in the room.

→ _____, I found that no one was in the room.

5 As she went upstairs, she tried not to make any noise.

→ _____, she tried not to make any noise.

6 As soon as she received the flowers, her face turned red.

→ _____, her face turned red.

7 Because I have enough time, I can attend the birthday party.

→ _____, I can attend the birthday party.

8 I played a smartphone game while I was waiting for a bus.

→ I played a smartphone game, _____.

9 He said goodbye to his mother and left home.

→ _____, he left home.

10 Since my brother is too young, he can't watch the movie.

→ _____, my brother can't watch the movie.

STEP 2

다음 밑줄 친 분사구문의 의미로 가장 적절한 것을 고르세요.

1 Feeling tired, I went to bed early.

① 피곤했기 때문에　　　　　　　② 피곤하고 나서

2 Listening to the speech, he took a note of it.

① 연설을 들으면서　　　　　　　② 연설을 들었기 때문에

3 Washing their hands, they started to cook.

① 손을 씻다가　　　　　　　　　② 손을 씻고 나서

4 Eating food, I found a hair in the dish.

① 음식을 먹어서　　　　　　　　② 음식을 먹다가

5 I could win a prize following his advice.

① 그의 충고를 따랐기 때문에　　② 그의 충고를 따르는 동안에

STEP 3

주어진 분사구문을 절로 바꿔 쓸 때, 문맥상 가장 자연스러운 접속사를 괄호 안에서 고르세요.

1 The bus departs at seven, arriving in Daejeon at eight.

→ The bus departs at seven [and / after] it arrives in Daejeon at eight.

2 Being too young to understand the story, I was just listening.

→ [After / Because] I was too young to understand the story, I was just listening.

3 Taking a shower, she was surprised by a loud noise from outside.

→ [While / And] she was taking a shower, she was surprised by a loud noise from outside.

4 Finishing her homework, she went out to play.

→ [While / After] she finished her homework, she went out to play.

5 Looking at the watch, he told everyone to hurry up.

→ He looked at the watch [and / since] he told everyone to hurry up.

Unit 32

내신
적중
Point

Point 01 문장 전환이 잘못된 것 찾기
분사구문이 나타내는 의미를 제대로 파악해서 적절한 접속사를 포함한 부사절로 바꿀 수 있어야 해요.

Point 02 그림의 상황 묘사하기
분사구문을 이용해서 그림이 나타내는 상황을 간결하게 표현할 수 있어요.

정답 및 해설 p.11

Point 01

● **다음 중 문장 전환이 <u>잘못된</u> 것은?**

① Feeling happy, I sang loudly.
 → Because I felt happy, I sang loudly.
② Smiling brightly, she answered the question.
 → Since she smiled brightly, she answered the question.
③ Traveling to Africa, she became interested in protecting animals.
 → When she traveled to Africa, she became interested in protecting animals.
④ Taking a few steps forward, he looked around.
 → He took a few steps forward, and looked around.
⑤ Doing her homework, she listened to the music.
 → While she was doing her homework, she listened to the music.

Point 02

서술형 ▶

● **다음 그림의 상황을 주어진 〈조건〉에 맞게 문장으로 써 보세요.**

〈조건〉	• 분사구문을 사용할 것
	• 총 5단어로 쓸 것
	• watch TV, fall asleep, he를 적절한 형태로 쓸 것

→ _____ on the sofa.

주의해야 할 분사구문

부정이나 완료시제, 수동의 의미를 갖는 분사구문의 형태를 주의해서 알아두어야 해요.

A 분사구문의 부정형

not[never]+v-ing

분사구문의 부정형은 분사(v-ing) 바로 앞에 부정어를 써줍니다.

- **Not knowing** what to say, he remained silent. 부정형: not[never]+v-ing

 (← *As he didn't know* what to say, he remained silent.)

- **Never eating** meat, he wouldn't choose to eat steak.

 (← *Since he never eats* meat, he wouldn't choose to eat steak.)

B 수동형 분사구문

(Being)+p.p.

분사구문이 과거분사(p.p.)로 시작하는 경우 수동의 의미를 나타내요. 수동태(be+p.p.)인 부사절의 동사가 분사구문에서 「being+p.p.」로 바뀐 것이지요. 이때 _____ 은 종종 생략되기도 해요.

- **(Being) Written** in haste, it had some mistakes. 수동형: (Being)+p.p.

 (← Because it *was written* in haste, it had some mistakes.)

- **(Being) Caught** by the police, the thief went to jail.

 (← The thief *was caught* by the police, and he went to jail.)

C 완료형 분사구문

Having+p.p.

분사구문이 나타내는 때가 문장의 시제보다 앞선 시점을 나타낼 때는 분사를 완료형(Having+p.p.)으로 써요.

- **Having walked** all the way, she *is* tired. 완료형: Having+p.p.

 (← Because she **walked** all the way, she *is* tired.)

- **Having cleaned** the kitchen, Barry *phoned* his friend.

 (← After Barry **had cleaned** the kitchen, he *phoned* his friend.)

PRACTICE

정답 및 해설 p.11

STEP 1

다음 문장을 분사구문으로 바꿔 쓰세요.

1 As soon as she was left alone, she began to feel sad.

→ _____, she began to feel sad.

2 Because he didn't know the answer, he said nothing.

→ _____, he said nothing.

3 After the machine is used, it should be cleaned.

→ _____, the machine should be cleaned.

4 After I had finished my report, I went to bed.

→ _____, I went to bed.

5 Since he doesn't have a car, he uses public transportation.

→ _____, he uses public transportation.

6 When the player was elected as a captain, he was happy.

→ _____, the player was happy.

7 Because they have traveled a lot, they enjoy all kinds of foods.

→ _____, they enjoy all kinds of foods.

8 Since my cell phone was dropped on the ground, it broke.

→ _____, my cell phone broke.

9 As the food was cooked by my grandma, it tasted great.

→ _____, the food tasted great.

10 As he didn't write his name on the sheet, he failed the test.

→ _____, he failed the test.

..

PRACTICE

STEP 2

괄호 안에서 어법에 맞는 것을 고르세요.

1 [Using / Used] for a long time, the computer broke down.

2 [Surprised / Having surprised] by a barking dog, Kate dropped a glass.

3 [Not had / Not having] a correct address on it, the letter was returned.

4 [Having forgotten / Being forgotten] to bring the tickets, they couldn't enter the theater.

5 [Having lost / Being lost] the money, I can't buy the backpack.

6 [Having not / Not having] enough time, I take a taxi.

7 [Finishing / Having finished] my homework, I don't have anything to do.

8 [Surrounding / Surrounded] by a forest, the house has a beautiful view.

9 [Being touched / Having touched] by the movie, they were in tears.

STEP 3

우리말과 뜻이 같도록 괄호 안의 말을 이용해서 분사구문으로 쓰세요.

1 그 선수는 부상을 입어서 병원으로 실려 갔다. (injure)

→ _____ _____, the player was taken to the hospital.

2 신문을 읽었기 때문에 나는 그 사고에 대해 안다. (the newspaper, read)

→ _____ _____ _____ _____, I know about the accident.

3 나는 몸이 좋지 않아서 학교에 가지 않았다. (feel well)

→ _____ _____ _____, I didn't go to school.

4 우리는 그 소식을 듣고서 기쁨의 환호를 질렀다. (the news, tell)

→ _____ _____ _____, we shouted for joy.

Point 01 어법상 틀린 것 찾기

분사구문의 부정형, 완료형과 수동의 의미를 갖는 분사구문의 올바른 형태를 파악할 수 있어야 합니다.

Point 02 조건에 맞게 영작하기

분사구문의 동사가 수동의 의미를 가지면 분사를 수동형(Being+p.p.)으로 써야 해요.

정답 및 해설 p.12

Point 01

● 다음 중 어법상 **틀린** 것은?

① Not knowing her, I kept silent.

② Being told a story, we became shocked.

③ Having not enough money, I can't enjoy shopping.

④ Given the first prize, she felt proud.

⑤ Having finished dinner, dad washed the dishes.

Point 02

서술형 ▶

● 다음 우리말을 괄호 안에 주어진 단어를 이용해서 〈조건〉에 맞게 영어로 옮기세요.

그 주자는 친구들에게 응원을 받아서 마라톤을 완주할 수 있었다.

(by his friends, support)

| 〈조건〉 | • 분사구문을 사용할 것 |
| | • 4단어로 쓸 것 |

→ _____ , the runner could finish the marathon.

Overall Exercises 13

[1-4] 다음 빈칸에 알맞은 말을 고르세요.

1

_____ the exam, Cindy kept shaking her leg.

① Take
② Taking
③ Taken
④ Having taken
⑤ Being taken

2

_____ from the sky, the island looks like a heart.

① See
② Seeing
③ Saw
④ Seen
⑤ Not seeing

3

_____ dark colors, he wouldn't buy a black shirt.

① Like
② Being liked
③ Not liking
④ Having liked
⑤ Not having liked

4

_____ suddenly cold and dark, we hurried back to our home.

① Become
② Became
③ Becoming
④ Having become
⑤ It becoming

[5-7] 두 문장의 뜻이 같도록 빈칸에 알맞은 말을 고르세요.

5

Since he moved to Australia, he has made terrific improvements in his English.

= _____ to Australia, he has made terrific improvements in his English.

① Moving
② Having moved
③ Moved
④ Not moving
⑤ Being moved

6

Taking a walk for an hour, we stopped to have lunch at a restaurant.

= _____ we took a walk for an hour, we stopped to have lunch at a restaurant.

① While
② Before
③ And
④ Though
⑤ After

7

When she was asked to help with the project, she refused.

= _____ to help with the project, she refused.

① Asking
② Been asking
③ Asked
④ Having asked
⑤ Having been asked

8 다음 중 문장 전환이 바르지 <u>않은</u> 것은?

① Living abroad, I sometimes feel lonely.
→ Because I live abroad, I sometimes feel lonely.
② Waving his hand, he said goodbye to me.
→ As he waved his hand, he said goodbye to me.
③ Wanting some fresh air, she went outside.
→ Since she wanted some fresh air, she went outside.
④ Having nothing to do, we went to bed early.
→ Because we had nothing to do, we went to bed early.
⑤ Having drunk too much, he didn't drive himself home.
→ As he has drunk too much, he didn't drive himself home.

9 다음 중 주어진 우리말을 영어로 바르게 옮긴 것은?

> 선생님께 칭찬을 받아서, 나는 기분이 아주 좋았다.

① Praising by the teacher, I felt so good.
② As praising by the teacher, I felt so good.
③ Having praised by the teacher, I felt so good.
④ Praised by the teacher, I felt so good.
⑤ Being praising by the teacher, I felt so good.

10 밑줄 친 부분이 어법상 틀린 것은?

① <u>Smiling</u> brightly, Katie looked at me.
② <u>Watching</u> a movie, he ate popcorn.
③ <u>Treating</u> without care, the vase was broken.
④ <u>Having</u> a cold, I usually drink ginger tea.
⑤ <u>Left alone</u>, the girl was afraid.

[11-12] 빈칸에 들어갈 말로 바르게 짝지어진 것을 고르세요.

11

> • _____ Brian falling asleep, I shook his shoulder to wake him up.
> • _____ his car key, he couldn't drive his car.

① Seeing	Not finding
② Seeing	Finding not
③ Seen	Not finding
④ Seen	Having found
⑤ Having seen	Found

12

> • Mike lives in Korea, _____ as an English teacher.
> • _____ allowance, I always put it into the bank.

① works	Giving
② worked	Given
③ working	Giving
④ working	Given
⑤ having worked	Being given

13 다음 문장을 분사구문으로 바르게 바꿔 쓴 것은?

> As I felt tired, I slept over twelve hours.

① Felt tired, I slept over twelve hours.
② Being felt tired, I slept over twelve hours.
③ Feeling tired, I slept over twelve hours.
④ I feeling tired, I slept over twelve hours.
⑤ Not feeling tired, I slept over twelve hours.

[14-15] 다음 중 어법상 틀린 문장을 고르세요.

14 ① Locked tightly, the door doesn't open easily.
② Having breakfast, my sister brushes her teeth.
③ Shouted loudly, the crowd cheer the team.
④ Finishing his meal, he walked his dog.
⑤ Having eaten too much, I can't eat any more.

15 ① Not being rich, he can't buy the car.
② Snowing a lot, the roads were icy.
③ Knowing the answer, I raised my hand.
④ Helped by my brother, I could finish my essay.
⑤ Having prepared a lot, she won the contest.

[16-17] 다음 문장에서 어법상 틀린 곳을 바르게 고치세요.

16
> Remembering not his name, I was embarrassed.

_____ → _____

17
> Adding too much salt, the soup will be too salty. Don't put too much.

_____ → _____

[18-20] 다음 글을 읽고 물음에 답하세요.

> Last Saturday, I went to Gangneung by train with my friend Ben. (A) When I waited for him at the station, I felt very happy. We arrived in Gangneung and went to a famous restaurant first. (B) Having delicious food there, we went to the beach. (C) While we were walking along the beach, we talked about many things. I will never forget our time in Gangneung.

18 윗글의 밑줄 친 (A)를 분사구문으로 알맞게 바꾼 것은?

① Wait for him at the station
② Waiting for him at the station
③ Having waited for him at the station
④ Waited for him at the station
⑤ Being waited for him at the station

19 윗글의 밑줄 친 (B)를 다음과 같이 바꿔 쓸 때 빈칸에 가장 적절한 말은?

> → _____ we had delicious food there, we went to the beach.

① While ② Because ③ If
④ When ⑤ After

20 윗글의 밑줄 친 (C)를 분사구문으로 바꾸세요.

→ _____

⟨서술형 만점⟩ Writing Exercises

1 우리말과 같은 뜻이 되도록 괄호 안의 단어와 분사구문을 이용하여 문장을 완성하세요.

(1)

> 그는 돈이 충분하지 않아서 새 스마트폰을 살 수 없었다. (money, have, enough)

→ _____, he couldn't buy a new smartphone.

(2)

> 그는 종일 일했기 때문에 매우 피곤하다. (work, all day)

→ _____, he is very tired.

2 두 문장의 뜻이 같도록 빈칸에 알맞은 말을 쓰세요.

(1)

> Since I didn't know the password, I couldn't log onto the website.

→ _____ _____ _____ _____, I couldn't log onto the website.

(2)

> As I slept enough last night, I feel good now.

→ _____ _____ _____ last night, I feel good now.

(3)

> Finishing your meal, you should wash your own dishes.

→ _____ _____ _____ _____ _____, you should wash your own dishes.

3 주어진 문장을 괄호 안의 지시대로 바꿔 쓰세요.

(1)

> While he was talking on the phone, he heated up the pizza to have for lunch.

→ (분사구문 사용) _____

_____.

(2)

> Touched by their warm welcome, she cried.

→ (부사절 사용) _____

_____.

4 괄호 안에 주어진 말과 분사구문을 이용해서 그림을 묘사하는 문장을 완성하세요.

(look at, stand, on the beach)

→ _____, they are _____ the moon.

.CHAPTER.

14

가정법

| 기본 개념 & 용어 Review |

가정법 과거 또는 현재의 사실을 반대로 가정하거나, 실제로 일어나기 어려운 일을 가정할 때 써요.

if 가정법 과거 만약 ~라면 …일[할] 텐데

If + 주어 + 동사의 과거형 ~, 주어 + would[could, might] + 동사원형 …

if 가정법 과거완료 만약 ~했다면 …했을 텐데

If + 주어 + had p.p. ~, 주어 + would[could, might] + have p.p. …

if가 아닌 다른 표현으로도 가정법을 나타낼 수 있어요.

I wish 가정법 ~하면 좋을 텐데 / ~했다면 좋을 텐데

as if 가정법 마치 ~인 것처럼

Without[But for] + 명사(구) ~이 없다면 / ~이 없었다면

Unit 34 if 가정법 과거/과거완료

사실과 반대되는 일이나 실현 가능성이 거의 없는 일을 가정하거나 소망할 때 가정법을 씁니다.

A if 가정법 과거

If + 주어 + 동사의 과거형 ~, 주어 + would[could, might] + 동사원형 …

'만약 ~라면 …일[할] 텐데'라는 뜻으로, 현재 사실과 반대로 가정하거나 현재나 미래에 실현 가능성이 희박한 일을 가정할 때 쓰여요. (조)동사의 **1** _____ 형이 쓰이지만 과거의 일을 말하는 것이 아님에 주의하세요.

- If I **were not** busy, I **would travel** abroad.
 (← As I *am* busy, I *won't travel* abroad.)
- If he **had** enough money, he **could buy** a new car.
 (← As he *doesn't have* enough money, he *cannot buy* a new car.)
- What would you do **if** you won the lottery?　의문문 + if절

*가정법에서 if절의 be동사는 인칭과 수에 관계없이 **2** _____ 를 쓰는 것이 원칙이지만, 구어에서는 was도 써요.

> **More** 조건을 나타내는 if절과 가정법 과거
>
> '~한다면'이라는 뜻으로 실제 일어날 수 있는 상황을 가정할 때 가정법이 아니라 단순 조건절(직설법)로 나타냅니다.
> **If** it **rains** tomorrow, the game **will be canceled**. (단순 조건문 – 비가 올 가능성이 있음)
> **If** it **rained**, I **would stay** indoors. (가정법 과거 – 비가 올 가능성이 희박)

B if 가정법 과거완료

If + 주어 + had p.p. ~, 주어 + would[could, might] + have p.p. …

'만약 ~했다면 …했을 텐데'라는 뜻으로, 과거의 사실을 반대로 가정하거나, 과거에 실현 가능성이 희박했던 일을 가정할 때 가정법 과거완료를 써요.

- If he **had studied** hard, he **would have passed** the exam.
 (← He *didn't study* hard, so he *didn't pass* the exam.)
- If I **had had** a lot of money, I **could have bought** a boat.
 (← As I *didn't have* a lot of money, I *couldn't buy* a boat.)
- If you **had not been** so lazy, you **might not have missed** the train.
 (← Since you *were* so lazy, you *missed* the train.)
- If he **hadn't slept** enough, he **would have fallen asleep** during class.
 (← As he *slept* enough, he *didn't fall* asleep during class.)
- It would have been better **if** everybody had attended.　주절 + if절

PRACTICE

STEP

1

주어진 문장을 가정법으로 바꿔 쓸 때, 빈칸에 들어갈 말을 쓰세요.

1 As I don't have a motorcycle, I can't give you a ride.

→ If I _____ a motorcycle, I _____ you a ride.

2 As I don't know his phone number, I cannot call him.

→ If I _____ his phone number, I _____ him.

3 Because he didn't obey the speed limit, he was injured.

→ If he _____ the speed limit, he _____ .

4 As the police officer is with me, I feel safe.

→ If the police officer _____ with me, I _____ .

5 Since he lost the money, he couldn't afford a new car.

→ If he _____ the money, he _____ a new car.

6 I have no time, so I cannot solve the problem.

→ If I _____ time, I _____ the problem.

7 It is raining, so I cannot walk my dog.

→ If it _____ , I _____ my dog.

8 As a fire alarm didn't ring, we didn't know that a fire had broken out.

→ If a fire alarm _____ , we _____ that a fire had broken out.

9 Because you didn't drive safely, you hit the dog.

→ If you _____ safely, you _____ the dog.

10 As I didn't know you were leaving, I didn't come to see you off.

→ If I _____ you were leaving, I _____ to see you off.

PRACTICE

괄호 안에 주어진 단어를 어법과 문맥에 알맞은 형태로 바꿔 빈칸에 쓰세요.

1 (may, feel)

→ I _____ disappointed if I failed the test.

2 (will, accept)

→ If I were you, I _____ their invitation.

3 (try)

→ If you _____ the steak, you would have liked it.

4 (arrive)

→ If she _____ at home on time, her parents would worry about her.

5 (know)

→ If I _____ his address, I could have visited him.

→ If I _____ his address, I would send him a Christmas card.

6 (leave)

→ If you _____ home now, you would be in time for the train.

→ If you _____ home then, you would not have been late for the meeting.

7 (have)

→ If I _____ a talent for singing, I would have become a singer.

→ If I _____ a talent for poetry, I would write a poem for her.

다음 중 주어진 문장과 의미가 통하는 것을 고르세요.

1 If I had to clean the house today, I would need some help.

① As I have to clean the house today, I don't need any help.

② As I don't have to clean the house today, I don't need any help.

2 If he had seen the musical, he would have felt excited.

① He didn't see the musical, so he didn't feel excited.

② He saw the musical, but he didn't feel excited.

STEP
4

괄호 안에서 어법에 맞는 것을 고르세요.

1 If I [know / knew] Fred's e-mail address, I would send him an e-mail.

2 I don't blame you. I would do the same if I [am / were] in your position.

3 If they had more time, they [might stay / might have stayed] longer in the city.

4 If I hadn't slipped on the stairs, I [wouldn't break / wouldn't have broken] my arm.

5 If she had come in for an interview, I [would give / would have given] her the job.

6 If there [were / had been] no trees, all life on Earth would die.

7 If I [knew / had known] that you wanted to give your bike to me, I would never have bought this bike.

8 If I [am / were] a superhero, I would rescue people in danger.

9 The trip would have been better if the weather [were / had been] nicer.

10 It [would be / would have been] wonderful if I could drive.

STEP
5

밑줄 친 부분이 어법상 맞으면 ○표, 틀리면 ✕표 하고 바르게 고치세요.

1 If I were you, I would have done a part-time job.

2 If she had read the book, she might have found a leaf in it.

3 Our team would have won the game if Chris didn't hurt his leg.

4 If I had a talent in cooking, I could become a chef and open a restaurant.

5 If he had heard the news, he would be shocked.

STEP
6
우리말과 뜻이 같도록 괄호 안의 단어를 이용하여 문장을 완성하세요.

1 내가 영어를 유창하게 한다면 영어 말하기 대회에 나갈 텐데. (speak, fluently, English)

→ _____, I might enter an English speech competition.

2 내가 그 책을 가지고 있었다면 너에게 빌려줬을 텐데. (have, lend, it, the book, to you, will)

→ If _____.

3 그가 아프지 않다면 수업에 참석할 수 있을 텐데. (the class, be sick, can, attend)

→ If _____.

4 우리가 신중히 생각했다면 잘못된 결정을 내리지 않았을 텐데.
(make, think, may, a wrong decision, carefully)

→ If _____.

5 네가 그 미술관에 방문했다면 Monet의 그림들을 볼 수 있었을 텐데.
(see, can, the art museum, visit, Monet's paintings)

→ If _____.

6 그가 매일 운동한다면 건강해질 텐데. (work out, healthy, daily, become, will)

→ He _____.

7 그녀가 외국에서 산다면 다양한 문화권의 친구들을 사귈 텐데.
(make friends, live, from different cultures, will, abroad)

→ If _____.

8 그들이 미리 예약했다면 좋은 자리에 앉을 수 있었을 텐데.
(in advance, sit at a good table, can, make a reservation)

→ If _____.

Unit 34

내신
적중

Point

Point 01 대화 완성하기
문맥과 어울리는 가정의 말을 가정법을 통해 표현해 보세요.

Point 02 문장 전환하기
현재나 과거의 사실을 나타낸 문장을 보고 반대로 가정하는 문장을 쓸 수 있어요.

정답 및 해설 p.13

Point
01

● 다음 대화의 빈칸에 가장 적절한 것은?

> A: I really don't have time to do all this work.
> B: _____ There must be someone who can help you.

① If I had time, I would get some sleep.
② If I were you, I would ask for some help.
③ If you were me, you could not finish all the work.
④ If I were you, I would help someone in trouble.
⑤ If you had time, what would you do?

Point
02

서술형 ▶

● 주어진 문장을 〈보기〉와 같이 바꿔 쓰세요.

〈보기〉 As you are not our member, you cannot get a discount.
→ If you were our member, you could get a discount.

As she didn't understand it, she asked me twice.

→ If _____ .

Unit 35

I wish/as if/Without[But for] 가정법

if를 사용하지 않고도 가정의 의미를 나타내는 표현들이 있어요.

A I wish 가정법

❶ I wish + 가정법 과거: (현재) ~하면 좋을 텐데

현재 이루기 힘든 일을 소망하거나 현재 사실에 대한 유감이나 아쉬움을 나타내요.

- **I wish I were** rich. → I want to be rich, but I **am not.**
- **I wish I could go** there. → I want to go there, but I **cannot go.**

❷ I wish + 가정법 과거완료: (그때) ~했다면 좋을 텐데

과거에 이루지 못한 일에 대한 아쉬움이나 과거 사실과 반대되는 것을 소망하는 표현이에요.

- **I wish I had been** rich. → I wanted to be rich, but I **was not.**
- **I wish I had gone** there. → I'm sorry that I **didn't go** there.
- **I wish I had studied** harder. → I regret that I **didn't study** harder.

> **More** It's time+가정법 과거: ~해야 할 때이다
> 마찬가지로 가정법 if절 대신 쓰여서 해야[했어야] 할 일을 하지 않은 것에 대한 유감을 나타내요.
> **It's time** you **were** in bed. It's so late.

B as if 가정법 과거

'마치 ~인 것처럼'이라는 의미로, 주절과 '같은 때'를 나타냅니다.

❶ 주절이 현재: (현재) 마치 ~인 것처럼 …한다

- You *act* **as if** you **were** angry.
 현재시제 현재 사실과 반대
 (→ You *are not* angry, but you *act* like that.)

❷ 주절이 과거: (그때) 마치 ~인 것처럼 …했다

- You *acted* **as if** you **were** angry.
 과거시제 과거 사실과 반대
 (→ You *were not* angry, but you *acted* like that.)

C Without [But for] +명사(구)

❶ Without[But for]+명사(구), 주어+would[could, might]+동사원형 …

가정법의 if절을 대신하는 표현으로, 가정법 과거 문장에서 '~이 없다면'으로 해석해요.

- **Without** love, we **could not survive.**
- = **But for** love, we **could not survive.** = If it were not for ~, …

❷ Without[But for]+명사(구), 주어+would[could, might]+have p.p. …

가정법 과거완료 문장에서 '~이 없었다면'으로 해석해요.

- **Without** your help, it **would have been** impossible.
- = **But for** your help, it **would have been** impossible.

= If it had not been for ~, …

PRACTICE

STEP 1

주어진 문장을 I wish 가정법을 이용하여 바꿔 쓴 문장을 완성하세요.

1 I want to talk with you, but I don't have time.

→ I wish I _____ time to talk with you.

2 I'm sorry that I didn't know about this skate spot earlier.

→ I wish I _____ about this skate spot earlier.

3 I want to go shopping with my classmates, but I can't.

→ I wish I _____ with my classmates.

4 I regret that I missed the last science class.

→ I wish I _____ the last science class.

5 I want Kate to be here now, but she isn't.

→ I wish Kate _____ here now.

6 I regret that I didn't attend his wedding ceremony.

→ I wish I _____ his wedding ceremony.

7 I'm sorry I heard the news so late.

→ I wish I _____ the news earlier.

STEP 2

우리말과 뜻이 같도록 괄호 안의 단어를 알맞은 형태로 바꿔 쓰세요.

1 그녀는 언니가 없지만 종종 언니가 있는 것처럼 말한다. (speak, have)

→ She doesn't have a sister, but she often _____ as if she _____ one.

2 그들은 마치 매우 기쁜 것처럼 행동했다. (act, be)

→ They _____ as if they _____ very happy.

3 Sandra는 마치 그 영화배우를 아는 것처럼 이야기했다. (talk, know)

→ Sandra _____ as if she _____ the actor.

4 그 남자는 마치 억만장자인 것처럼 돈을 썼다. (spend, be)

→ The man _____ money as if he _____ a billionaire.

PRACTICE

STEP 3

우리말과 뜻이 같도록 괄호 안의 단어를 이용하여 문장을 완성하세요.

1 매일 눈이 온다면 좋을 텐데. (every day, snow, it)

→ I wish _____ .

2 미세먼지가 없다면 하늘이 맑을 텐데. (the sky, be, fine dust, clear, without, will)

→ _____ .

3 그는 마치 자신이 VIP 고객인 것처럼 말했다. (a VIP customer, speak, as if, be)

→ _____ .

4 내가 그 영화를 극장에서 봤다면 좋을 텐데. (the movie, see, in a theater)

→ I wish _____ .

5 너의 지지가 없었다면, 나는 성공할 수 없었을 텐데. (succeed, but for, support, can, your)

→ _____ .

STEP 4

가정법을 이용해 바꿔 쓴 문장에서 틀린 부분을 찾아 바르게 고치세요.

1 I want to play the piano, but I can't.
→ I wish I could have played the piano.

_____ → _____

2 She speaks Korean very fluently, but she is not Korean.
→ She speaks as if she is Korean.

_____ → _____

3 I'm sorry that I didn't meet you when I was young.
→ I wish I met you when I was young.

_____ → _____

4 She had a busy day at work, so she needs a break.
→ It's time she takes a break from her work.

_____ → _____

Point 01 의미가 같은 문장 찾기
현재나 과거 사실의 반대를 가정하는 문장을 보고 상황을 유추할 수 있어야 합니다.

Point 02 조건에 맞게 영작하기
현재나 과거 사실과 반대되는 것을 소망할 때 「I wish + 가정법 과거[과거완료]」로 표현할 수 있어요.

정답 및 해설 p.14

Point 01

● 주어진 문장이 의미하는 바로 알맞은 것은?

> I wish you had told me the truth.

① I'm sorry that you told me the truth.
② I'm sorry that you don't tell me the truth.
③ I'm sorry that you didn't tell me the truth.
④ I was sorry that you told me the truth.
⑤ I was sorry that you didn't tell me the truth.

Point 02

서술형 ▶
● 밑줄 친 우리말과 같은 뜻이 되도록 〈조건〉에 맞게 영작하세요.

> The concert tickets are sold out. 내가 그 콘서트에 갈 수 있으면 좋을 텐데.
>
〈조건〉	• I wish를 사용할 것
> | | • 8 단어로 쓸 것 |

→ _____

Overall Exercises 14

[1-4] 다음 중 어법과 문맥상 빈칸에 가장 적절한 말을 고르세요.

1

> If I _____ the subway, I could be there on time.

① take ② don't take
③ took ④ have taken
⑤ would take

2

> If I _____ that today is your birthday, I would have brought a present for you.

① know ② would know
③ knew ④ have known
⑤ had known

3

> My hair is so short. I wish I _____ long hair like Betty.

① have ② had
③ have had ④ had had
⑤ don't have

4

> A: We lost the game.
> B: How come? You could have won if you _____ your best.

① do ② did
③ does ④ have done
⑤ had done

5 **대화의 빈칸에 들어갈 말로 바르게 짝지어진 것은?**

> A: I lost interest in this book. I read a bad review about its ending.
> B: If you _____ the end of the story, it _____ more interesting.

① know ······ will be
② knew ······ won't be
③ knew ······ would be
④ didn't know ······ would be
⑤ hadn't known ······ wouldn't be

6 **다음 중 문장 전환이 잘못된 것은?**

① As you didn't water the plant, it died.
→ If you had watered the plant, it wouldn't have died.
② Because she told the truth, I understood the situation.
→ If she hadn't told the truth, I couldn't have understood the situation.
③ As he didn't do well at school, he didn't find a job quickly.
→ If he did well at school, he would have found a job quickly.
④ Because Amy was busy, she didn't answer the phone.
→ If Amy hadn't been busy, she would have answered the phone.
⑤ As I don't have enough money, I can't buy the house.
→ If I had enough money, I could buy the house.

7 주어진 문장과 의미가 통하는 것은?

> If I were taller, I could be a model.

① As I'm tall, I can be a model.
② As I'm not tall, I can be a model.
③ As I'm not tall, I can't be a model.
④ As I was tall, I could be a model.
⑤ As I wasn't tall, I couldn't be a model.

8 다음 빈칸에 적절한 말은?

> Tim looked as if he were hungry.
> → In fact, _____

① Tim is hungry.
② Tim isn't hungry.
③ Tim was hungry.
④ Tim wasn't hungry.
⑤ Tim will be hungry.

[9-10] 주어진 문장과 의미가 같도록 문장을 완성하세요.

9

> If the show hadn't been delayed, the audience wouldn't have complained.

→ The show _____, so the
 audience _____.

10

> As I didn't recognize him, I passed him by.

→ If I _____ him, I _____
 _____.

[11-12] 다음 중 어법과 문맥상 바른 문장을 고르세요.

11 ① It's time we talk about it.
② If I have enough time, I would walk with you.
③ My brother acted as if he were asleep.
④ I wish you tell me the truth.
⑤ If I am you, I would take the chance.

12 ① I wish I have supernatural powers right now.
② If were I you, I would accept her apology and forgive her.
③ He always acts as if he is the boss.
④ If you had saved more money, you could have bought the guitar.
⑤ I wish he were more careful when he took the entrance exam.

13 다음 대화의 빈칸에 가장 적절한 말은?

> A: Matt is acting in a play tonight. Are you going to go to watch it?
> B: _____ I have too much to do tonight.

① I wish I could, but I can't.
② I wish I can, but I can't.
③ I wish I couldn't, but I can.
④ I wish I could, but I can.
⑤ I wish I could have gone, but I can.

[14-15] 다음 대화를 읽고 물음에 답하세요.

> A: Why didn't you call Cindy yesterday? It was her birthday.
> B: If I hadn't lost my cell phone yesterday, I ___(A)___ her.
> A: It's time you ___(B)___ (contact) her. She will be waiting for your call.

14 빈칸 (A)에 들어갈 말로 알맞은 것은?

① called　　　② didn't call
③ have called　　④ would call
⑤ would have called

15 빈칸 (B)에 주어진 괄호 안의 단어를 알맞은 형태로 바꿔 쓰세요.

[16-18] 다음 중 어법상 틀린 문장을 고르세요.

16 ① If I were born again, I would be an artist.
② If he helped me, I could do the job well.
③ I wish I had gone to bed early yesterday.
④ Without your donation, we would not have built this building.
⑤ She talked as if she knows my secret.

17 ① It's time you finished your homework.
② If I had known she was ill, I would have visited her.
③ They acted as if they knew nothing.
④ But for traffic jams, I might not be late for work every day.
⑤ I wish I took your advice at that time.

18 ① If I had been at home, I would have done the laundry.
② If we raised a dog, we would take good care of it.
③ I wish I have saved money for the future while I was young.
④ Brad talks as if his brother were in Europe.
⑤ Without her car, she could not have carried this luggage.

[19-20] 다음 대화를 읽고 물음에 답하세요.

> A: Ben complains about everything. I know he is a good friend, but I am tired of it.
> B: ___(A)___ If you're not honest with him, he will never know.
> A: That's a good idea. Thanks. (B) 너의 조언이 없었다면, I would not have figured this out.

19 빈칸 (A)에 들어갈 말로 가장 적절한 말은?

① I wish you thought more positively about everything.
② If I were you, I would not think so seriously.
③ I think it's time you stopped complaining.
④ If I were you, I would not get along with him.
⑤ If I were you, I would tell him how I feel.

20 밑줄 친 (B)를 영작할 때 괄호 안의 단어를 사용하여 빈칸을 완성하세요.

→ _____ _____ _____

_____ (advice)

Writing Exercises

1 괄호 안의 단어를 알맞은 형태로 바꾸어 빈칸에 쓰세요.

(1) A: If I _____ (know) you were coming today, I _____ (will, pick) you up at the airport.
 B: It's okay. The taxi only took ten minutes.

(2) A: Eva, can you read this?
 B: No, I can't. I wish I _____ (learn) French when I was young.

2 우리말과 같은 뜻이 되도록 괄호 안의 단어를 이용하여 문장을 완성하세요.

(1)
> 우리가 일찍 도착했다면 더 많은 사원들을 방문할 수 있었을 텐데.
> (visit more temples, arrive early, can)

→ If we _____
_____ .

(2)
> 그는 마치 자신이 대단한 사람인 것처럼 말한다.
> (be, talk, a great person, as)

→ He _____ .

(3)
> 비가 오네! 우산이 있으면 좋을 텐데.
> (an umbrella, have, wish)

→ It's raining! _____ .

3 다음 그림의 상황과 일치하도록 괄호 안의 단어를 이용하여 문장을 완성하세요.

(go surfing, will)

→ If I lived on the coast, _____
_____ every day.

4 다음 문장에서 어법상 틀린 곳을 찾아 고친 후 문장을 다시 쓰세요.

> If you kept the food in the refrigerator last night, it would not have gone bad.

→ _____

5 주어진 문장과 의미가 통하도록 다음 문장을 완성하세요.

> Because I don't have time, we can't go to the movies together.

→ If _____
_____ .

CHAPTER

15

비교

| 기본 개념 & 용어 Review |

형용사나 부사의 원급, 비교급, 최상급을 사용하면 어떤 상태나 정도의 차이를 좀 더 분명하게 나타 낼 수 있어요.

원급 A *as* `tall` *as* B (B만큼 키가 큰 A)

비교급 A `taller` *than* B (B보다 키가 더 큰 A)

최상급 A `the tallest` *of[in]* B (B중에서 키가 가장 큰 A)

원급을 이용한 비교

비교하려는 두 대상의 상태나 성질 등이 서로 비슷하거나 같을 때 'as ~ as' 형태로 표현할 수 있어요.

A 원급 비교

❶ as + 원급 + as: ~만큼 …한[하게]

as ~ as 사이에는 형용사나 부사의 원래 형태, 즉 **1**_____이 와요. 두 번째 as 뒤의 어구는 「주어 + 동사」

형태가 원칙이지만 종종 동사를 생략하며, 주어가 대명사이면 **2**_____형태를 자주 사용해요.

* Jihun is **as tall as** Suji (is). → as + 형용사 원급 + as
* The runner ran **as fast as** lightning. → as + 부사 원급 + as
* He is *as slim as* **she is**.
 → He is *as slim as* **her**.

> **More** as 뒤의 비교 대상의 형태
> * as 뒤의 동사는 비교하는 동사에 맞춰 「do동사/be동사/조동사」로 대신하여 씁니다.
> He *exercises* as often as I **do**.
> * 비교하는 두 대상은 동일한 형태, 격으로 써요.
> *Your bag* is as big as **mine**(= my bag).

❷ not as[so] + 원급 + as: ~만큼 …하지 않은[하지 않게]

* Where to live is **not as important as** how to live. → not as[so] + 형용사 원급 + as
* Henry can**not** run **so fast as** Dan. → not as[so] + 부사 원급 + as
 (= Dan can run faster than Henry.)

> **More** as ~ as 사이 형용사와 부사의 구분
> as ~ as 사이의 원급이 동사를 수식할 때는 형용사가 아니라 부사의 원급을 씁니다.
> My sister *cooks* as **good**(→ **well**) as mom.
> You *can have* as **many**(→ **much**) as you like.

B 원급을 이용한 관용표현

❶ as + 원급 + as possible: 가능한 한 ~하게

「as + 원급 + as 주어 + can[could]」로 바꿔 쓸 수 있어요.

* Call me **as soon as possible**. → = as soon as you can
* I tried **as hard as possible**. → = as hard as I could

❷ 배수사 + as + 원급 + as: ~의 … 배 더 ~한[하게]

배수사란 두 배, 세 배 …와 같이 어떤 수의 몇 배인지를 나타내는 말로 twice[two times], three[four, five, …] times로 표현해요.

* Seoul Tower is **twice as high as** this building.
* The star shines **three times as brightly as** the Sun.

PRACTICE

STEP 1 〈보기〉에서 알맞은 단어를 골라 다음 두 문장을 한 문장으로 바꿔 쓰세요. (단, 한 번씩만 쓸 것)

| 〈보기〉 | short | early | high | heavy | expensive |

1 My dad gets up at 7 a.m. I get up at 7 a.m., too.

→ I get up _____ my dad.

2 The rock is 3kg. These boxes are 3kg, too.

→ These boxes are _____ the rock.

3 Sam is 150cm. Yuri is 160cm.

→ Yuri is _____ Sam.

4 This book is 10 dollars. That magazine is 10 dollars, too.

→ That magazine is _____ this book.

5 My English score is 95 points. My math score is 90 points.

→ My math score is _____ my English score.

STEP 2 괄호 안에서 어법에 맞는 것을 고르세요.

1 The dog can run as [fast / faster] as the horse.

2 My hair is as long [as / than] yours.

3 Mike speaks Spanish as [fluent / fluently] as me.

4 My sister's bag is two times [so / as] big as mine.

5 Walking may be as [quick / quickly] as taking the bus.

6 I study as hard as James [is / does].

7 The teacher explained as slowly as she [can / could].

8 It is raining as [many / much] as yesterday.

PRACTICE

정답 및 해설 p.15

STEP 3

다음 우리말과 같도록 괄호 안의 단어를 배열하여 문장을 완성하세요.

1 그 뮤지컬은 그것의 영화만큼 재미있었다. (as, its, film, as, interesting)

→ The musical was _____.

2 나는 주말에 가능한 한 자주 책을 읽는다. (often, I, as, can, as)

→ I read books _____ on weekend.

3 기말고사는 중간고사만큼 어렵지 않았다. (difficult, as, not, as)

→ The final exams were _____ the mid-term exams.

4 중고제품이 신제품보다 세 배 더 저렴하다. (as, three, as, cheap, times)

→ Used products are _____ new ones.

STEP 4

괄호 안에 주어진 단어를 사용하여 문장을 완성하세요. (필요시 단어의 형태를 바꿀 것)

1 (possible, soon)

→ I should go home _____ after school.

2 (wide, as, can, as)

→ Please open your mouth _____.

3 (twice, as, large)

→ The new gym will be _____ the old one.

4 (I, as, long, can)

→ I wanted to stay there _____.

5 (three, as, as, expensive)

→ These jeans are _____ the shirt.

Unit 36 내신 적중 Point

Point 01 의미가 같은 것 찾기

「as+원급+as possible」을 절의 형태로 올바르게 바꿔 쓸 수 있어야 해요.

Point 02 도표와 일치하는 문장 완성하기

원급 표현을 사용하여 도표의 내용을 비교할 수 있어야 해요.

정답 및 해설 p.15

Point 01

● 다음 문장의 밑줄 친 부분과 의미가 같은 것은?

During the test, you should be <u>as careful as possible</u>.

① you should be more careful

② you don't have to be careful

③ you should do your best

④ you should be as careful as you can

⑤ you should be as careful as you used to be

Point 02

서술형 ▶

● 제품을 비교한 다음 표를 보고 〈조건〉에 맞게 문장을 완성하세요.

	Type A	Type B	Type C
Year	2015	2018	2018
Price	$350	$200	$350
Popularity	★★	★★	★★★

〈조건〉 • old, expensive, popular를 한 번씩 사용할 것

• as ~ as를 포함한 긍정문으로 쓸 것

*popularity: 인기

(1) Type A is _____ Type C.

(2) Type B is _____ Type C.

(3) Type A is _____ Type B.

Unit 37 비교급을 이용한 비교

두 대상을 비교하여 정도의 차이를 나타낼 때 형용사와 부사의 비교급을 사용하여 표현할 수 있어요.

A 비교급 비교

형용사[부사] 비교급(+명사)+than ~: ~보다 더 …한

* This blanket is **softer than** that one (is).
* She speaks Chinese **more fluently than** I (do).
* I need **a larger size** than this one.

> 형용사 비교급+than
> 부사 비교급+than
> 비교급+명사+than

> **More** than 뒤의 비교 대상
> * than도 뒤에 나오는 「주어+do동사/be동사/조동사」에서 동사를 생략하거나, 목적격 대명사를 쓰는 경우가 많아요.
> I can swim faster than *he* (**can**).
> = I can swim faster than **him**.

B 비교급의 강조·수식

much[even, still, far, a lot]+비교급

비교급 앞에서 '훨씬'이라는 의미로 비교급을 강조하거나 수식할 수 있어요. '조금'이라는 의미일 때는 (a) little을 두어 강조하기도 해요. 단, very, too, pretty 등은 비교급 앞에 쓸 수 없답니다.

* Henry is ***much*** smarter than you think.
* Finding a job is ***even*** more difficult than I thought.

C 비교급을 이용한 관용표현

❶ 비교급 and 비교급: 점점 더 ~한[하게]

비교급이 「more+원급」 형태일 때는 「more and more+원급」으로 나타냅니다.

* It's getting **colder and colder**.
* The world is changing **more and more rapidly**.

❷ The 비교급 ~, the 비교급 …: 더 ~할수록 더 …한

의미를 명확히 전달할 수 있을 때, the 비교급 뒤의 「주어+동사」는 종종 생략돼요.

* **The more** I know about her, **the more** I like her.
* **The higher** we go, **the colder** it becomes.
* **The sooner** (you go), **the better** (it will be).

> **More** the more 뒤에 이어지는 형용사, 부사, 명사의 어순
> **The more exercise** you do, **the more energetic** you'll be.
> (The more you do exercise, the more you'll be energetic. (×))

PRACTICE

STEP 1

문맥상 빈칸에 가장 어울리는 말을 〈보기〉에서 골라 비교급으로 바꿔 쓰세요. (단, 한 번씩만 쓸 것)

〈보기〉 well long cold early crowded comfortable

1 Some animals can live _____ than humans.

2 He arrived at the airport _____ than the departure time.

3 This sofa is _____ than that wooden chair.

4 My dad cooks _____ than my mom.

5 The town is _____ than the countryside.

6 The weather is becoming _____ and _____ .

STEP 2

주어진 단어를 사용하여 다음 두 문장을 한 문장으로 바꿔 쓰세요.

1 Brian is 15 years old. His sister is 16 years old. (young)

→ Brian is _____ his sister.

2 Today is 28°C. Yesterday was 27°C. (hot)

→ Today is _____ yesterday.

3 My class has 24 students. Mary's class has 20 students. (many)

→ My class has _____ Mary's class.

4 My allowance is 15,000 won a week. My brother's is 20,000. (little)

→ My allowance is _____ my brother's.

5 Taking the bus takes 20 minutes. Walking takes an hour. (fast)

→ Taking the bus is _____ walking.

STEP 3

괄호 안에서 어법과 문맥상 알맞은 것을 고르세요.

1 It is impossible to travel [fast / faster] than the speed of light.

2 The higher we go up, [the colder / more colder] it becomes.

3 This semester I learned more than I [do / did] last semester.

4 The movie was [much / many] more interesting than I expected.

5 The harder you practice, [soon / the sooner] your skills will improve.

6 Organic food is usually [far / very] healthier than junk food.

7 The game is getting [the more / more and more] exciting.

STEP 4

다음 우리말과 같도록 괄호 안의 단어를 배열하여 문장을 완성하세요. (필요시 단어의 형태를 바꿀 것)

1 그가 더 많이 말할수록 나는 더 지루해졌다.

(the, he, much, talked, the, much, I, bored, became)

→ _____ .

2 낮이 점점 더 길어지고 있다. (getting, long, the days, long, and, are)

→ _____ .

3 내 시험 성적은 내가 기대했던 것보다 훨씬 더 좋다.

(my, is, test score, I, expected, than, much, good)

→ _____ .

4 날씨가 나쁘면 평소보다 더 천천히 운전해야 한다. (drive, than, usual, you, must, slow)

→ _____ in bad weather.

Unit 37

정답 및 해설 p.16

Point 01 빈칸에 공통으로 들어갈 말 찾기

비교급을 강조하거나 수식할 수 있는 부사의 종류를 암기해두세요.

Point 02 도표와 일치하지 않는 문장 고르기

도표의 내용과 비교급 문장이 일치하는지 바르게 대조할 수 있어야 해요.

Point 01

● 다음 빈칸에 공통으로 들어갈 말로 알맞은 것은?

> • My new computer is _____ faster than the old one.
>
> • I think I can do it _____ better than you.
>
> • The cold weather made our task _____ more difficult.

① very
② many
③ much
④ too
⑤ most

Point 02

● 다음 도표의 내용과 일치하지 <u>않는</u> 것은?

	Age	Height	Family Members
Junhee	17	160	4
Sera	14	153	3
Mina	16	165	5

① Junhee is taller than Sera.

② Sera is younger than Mina.

③ Mina has more family members than Junhee.

④ Junhee is older than Mina.

⑤ Sera has more family members than Junhee.

최상급을 이용한 비교

셋 이상을 비교하여 그 중 하나가 다른 것들보다 어떤 성질이나 상태의 정도가 <u>가장 심하거나 가장 덜한 것</u>을 나타 낼 때 최상급을 사용할 수 있어요.

A 최상급 비교

the + 최상급(+명사) ~ of[in] …: … 중에서 가장 ~한[하게]

최상급 앞에 _____를 쓰고 뒤에는 보통 of나 in을 써서 범위를 한정해줄 수 있어요.

- This book is **the most interesting** *of these three*. | the + 최상급 + of[in] ~
- Who is **the fastest runner** *in your class*? | the + 최상급 + 명사 + of[in] ~
- This is **the best** experience *(that) I've ever had*. | the + 최상급 + 명사 + 절
 (지금껏) ~한 중에서

> **More** 부사의 최상급
> 부사의 최상급 앞 the는 생략할 수 있어요.
> Jihun always runs **(the) fastest** in my class.

B 최상급을 이용한 관용표현

one of the + 최상급 + 복수명사: 가장 ~한 … 중 하나

여럿 중 하나(one)를 가리키므로 반드시 복수명사가 따라오는 것에 주의하세요.

- It's **one of the oldest buildings** in the whole world.
- Health is **one of the most important parts** of our lives.

C 최상급의 의미를 나타내는 표현

원급·비교급을 이용한 최상급 표현

원급과 비교급을 가지고 최상급과 같은 의미를 나타낼 수 있어요.

Ben is **the tallest boy** in his class.	최상급
= Ben is **taller than any other boy** in his class.	비교급 + than any other ~
= **No (other) boy is as[so] tall as** Ben in his class.	No (other) ~ as[so] + 원급 + as ~
= **No (other) boy is taller than** Ben in his class.	No (other) ~ 비교급 + than ~

- Passion is **the most important thing** in life.
 = Passion is **more important than any other thing** in life.
 = **Nothing is as[so] important as** passion in life.
 = **Nothing is more important than** passion in life.

PRACTICE

정답 및 해설 p.16

STEP 1

다음 문장이 최상급의 의미를 갖도록 괄호 안에 주어진 단어를 알맞은 형태로 바꿔 쓰세요.

1 Ethiopia is one of _____ places in the world. (hot)

2 Kang's Diner is _____ restaurant around here. (bad)

3 Angela is one of _____ people I've met. (wonderful)

4 The author's novel is _____ book of all time. (great)

5 One of _____ holidays in Korea is Lunar New Year. (important)

*Lunar New Year: 음력설

6 The man is _____ comedian in Korea. (funny)

7 The river is _____ of all the rivers in the country. (deep)

8 Incheon International Airport is one of _____ airports in the world. (large)

STEP 2

괄호 안에서 어법에 맞는 것을 고르세요.

1 I think my mom is the [more / most] beautiful woman in the world.

2 Your dog is [most / the most] intelligent I've ever seen.

3 Traffic is one of the biggest [problem / problems] in modern cities.

4 No other invention is as [creative / more creative] as the wheel.

5 No place would be [good / better] than a beach for a summer vacation.

STEP 3

주어진 문장과 같은 뜻이 되도록 〈보기〉와 같이 문장을 완성하세요.

〈보기〉 Good health is the most important thing in your life.
(1) = Good health is <u>more important than any other thing</u> in your life.
(2) = Nothing is <u>as important as good health</u> in your life.
(3) = Nothing is <u>more important than good health</u> in your life.

1 He is the busiest person that I've ever known.
(1) = He is _____ that I've ever known.
(2) = No other person that I've ever known is _____.
(3) = No other person that I've ever known is _____.

2 What we order is the most expensive dish on the menu.
(1) = What we order is _____ on the menu.
(2) = No other dish on the menu is _____.
(3) = No other dish on the menu is _____.

3 The final exam was the most difficult test I've ever taken.
(1) = The final exam was _____ I've ever taken.
(2) = No other test I've ever taken was _____.
(3) = No other test I've ever taken was _____.

STEP 4

우리말과 뜻이 같도록 괄호 안의 단어를 사용하여 문장을 완성하세요.

1 설거지는 모든 집안일 중에서도 가장 귀찮은 일이다.
(the, annoying, all, chore, of, housework)
→ Washing dishes is _____.

2 도쿄는 세계에서 가장 붐비는 도시 중 하나이다. (crowded, one, city)
→ Tokyo is _____ in the world.

3 그 나라는 아시아에서 가장 급격하게 성장하고 있다. (country, than, rapidly, any other)
→ The country is growing _____ in Asia.

내신
적중
Point

Point 01 **의미가 다른 문장 찾기**
최상급 의미를 나타내는 원급, 비교급 표현을 알아두세요.

Point 02 **어법상 틀린 문장 찾기**
최상급 구문에 따른 명사의 단·복수형 구분에 주의하세요.

Point 03 **조건에 맞게 문장 전환하기**
비교급 구문을 사용하여 최상급의 뜻을 나타낼 수 있는 두 가지 방법을 알아두세요.

정답 및 해설 p.17

Point 01

● **다음 중 의미가 나머지와 다른 하나는?**

① Nothing is more important than family in my life.
② Family is more important than anything else in my life.
③ Family is the most important thing in my life.
④ Nothing is as important as family in my life.
⑤ Family is not so important in my life.

Point 02

● **다음 중 어법상 틀린 문장은?**

① In life, nothing is so valuable as time.
② He is the most handsome boy I've ever seen.
③ He is one of the best soccer player in England.
④ I want to stay in the largest room in this hotel.
⑤ Kevin is more generous than any other student in my class.

Point 03

서술형 ▶

● **주어진 문장과 뜻이 같도록 비교급을 이용하여 두 가지 문장을 완성하세요.**

I think fire is the greatest discovery in history.
= I think fire is _____ in history.
= I think _____ as fire.

Overall Exercises 15

[1-4] 어법과 문맥상 빈칸에 가장 적절한 말을 고르세요.

1

> My father is twice as _____ as my brother.

① tall ② taller
③ tallest ④ more tall
⑤ most tall

2

> Writing class is _____ of all my classes this semester.

① interesting ② more interesting
③ very interesting ④ much interesting
⑤ the most interesting

3

> Environmental problems are _____ more serious than ever before.

① very ② so ③ much
④ many ⑤ too

4

> A: When do you think we should plan the science project?
> B: We have a lot to do. The _____ we start, the better it will be.

① long ② a few ③ most
④ earlier ⑤ least

5 다음 중 의미가 나머지와 <u>다른</u> 하나는?

① Loving yourself is the most important thing.
② Nothing is as important as loving yourself.
③ Nothing is more important than loving yourself.
④ Loving yourself is more important than anything else.
⑤ Loving yourself is as important as any other thing.

6 대화의 빈칸에 적절한 말로 짝지어진 것은?

> A: This cell phone is _____ on the market but it has lots of functions.
> B: I know, but it's _____ than any other phone.

① thinner ······ more expensive
② the thinnest ······ more expensive
③ thinner ······ most expensive
④ the thinnest ······ most expensive
⑤ as thin ······ most expensive

7 다음 우리말과 뜻이 같도록 주어진 단어를 사용하여 빈칸에 알맞은 말을 쓰세요.

> 이것은 내가 본 가장 감동적인 영화 중 하나이다.
> (movie, touching)

→ This is _____ _____ _____
_____ _____ _____ I've ever seen.

8 다음 대화의 빈칸에 들어갈 수 <u>없는</u> 것은?

> A: There are so many people waiting in line. This place is really popular!
> B: Maybe we should come _____ earlier next time.

① even ② very ③ much
④ far ⑤ a lot

9 다음 우리말을 영어로 옮길 때 'twice'가 들어갈 위치로 알맞은 곳은?

> 나는 점심으로 그녀가 먹은 것의 두 배를 먹었다.
> → I ate ① as ② much ③ as she ④ did ⑤ for lunch.

10 다음 중 문장 전환이 <u>잘못된</u> 것은?

① The Han River is the most well-known river in Korea.
 = No other river in Korea is as well-known as the Han River.
② This is the largest bag in this shop.
 = This is larger than any other bag in this shop.
③ These new shoes are not as comfortable as my old shoes.
 = My old shoes are more comfortable than these new shoes.
④ Nothing is more exciting than watching a soccer game.
 = Watching a soccer game is the most exciting than any other thing.
⑤ Your cat is the cutest one I've ever seen.
 = No other cat I've ever seen is as cute as yours.

[11-13] 다음 중 밑줄 친 부분이 어법상 바른 문장을 고르세요.

11 ① To me, swimming is <u>more enjoyable</u> than running.
② To me, swimming is as <u>more enjoyable</u> as running.
③ To me, swimming is <u>enjoyable as</u> running.
④ To me, swimming is more enjoyable <u>as</u> running.
⑤ To me, swimming is <u>much enjoyable</u> than running.

12 ① This room is twice as <u>large</u> as mine.
② Doing yoga is better for your back <u>as</u> jogging.
③ She finds poetry <u>interesting</u> than fiction.
④ Tim is more interested in drawing than I <u>do</u>.
⑤ The night sky was <u>very</u> darker than the ocean.

13 ① Cats are as friendly to people <u>than</u> dogs.
② The last question was <u>more difficult in</u> the test.
③ We walked as fast as <u>we could</u>.
④ The tree is <u>as twice</u> tall as my house.
⑤ The story is getting <u>more interesting and interesting</u>.

14 다음 문장에서 어법상 <u>틀린</u> 것을 바르게 고치세요.

> I usually get up as early as my mom is.

_____ → _____

15 빈칸에 공통으로 들어갈 수 있는 것을 <u>모두</u> 고르세요.

> • His recent movie is _____ worse than his first one.
> • I became _____ more healthier than before.

① very ② many ③ a lot
④ still ⑤ most

[16-17] 다음 대화를 읽고 물음에 답하세요.

> A: What's your favorite fruit?
> B: For me, nothing is ___(A)___ (fresh) than a juicy watermelon in summer.
> A: Mmm. A peach from my grandfather's farm was the ___(B)___ (good) fruit I've ever had.
> B: I like them, too. (C) <u>Peaches are probably one of the most popular fruit in the world.</u>

16 위 대화의 (A), (B)에 들어갈 괄호 속 단어의 알맞은 형태는?

	(A)		(B)
①	fresh	……	good
②	freshest	……	better
③	fresher	……	better
④	fresher	……	best
⑤	freshest	……	best

17 위 대화의 밑줄 친 (C)에서 어법상 <u>틀린</u> 한 곳을 찾아 바르게 고치세요.

_____ → _____

18 다음 주어진 문장과 의미가 같도록 빈칸에 공통으로 들어갈 알맞은 말을 쓰세요.

> Russia is the largest country in the world.

(1) Russia is _____ than any other country in the world.

(2) No country is _____ than Russia in the world.

[19-20] 다음 글을 읽고 물음에 답하세요.

> Tornadoes are one of ⓐ <u>the most dangerous storm</u> in nature. Tornadoes cause a lot of damage to us. What can you do ⓑ <u>to stay safe</u> when a tornado comes? Here are a few tips. ⓒ <u>The best thing</u> you can do is to go to _____ of a building or home. Stay away from windows and ⓓ <u>keep</u> them tightly closed. If you follow these tips, you can stay ⓔ <u>safe</u> during a tornado.

19 윗글의 밑줄 친 ⓐ~ⓔ 중 어법상 <u>틀린</u> 것은?

① ⓐ ② ⓑ ③ ⓒ
④ ⓓ ⑤ ⓔ

20 문맥상 윗글의 빈칸에 가장 적절한 말은?

① the low floor
② the lower floor
③ the lowest floor
④ lowest floor
⑤ lower floor

Writing Exercises

1 다음 우리말과 같은 뜻이 되도록 괄호 안의 단어를 이용하여 문장을 완성하세요.

(1)
| 오늘 나는 세상에서 가장 행복한 사람이다. (person, happy, in the world) |

→ Today, I'm _____

_____ .

(2)
| 우리는 더 많이 가질수록, 더 많이 원한다. (much, have, want, we, the) |

→ _____

_____ .

(3)
| 그 행성은 지구의 다섯 배 더 크다. (five, big, as) |

→ The planet is _____
Earth.

2 다음 문장과 의미가 같도록 괄호 안의 지시대로 문장을 완성하세요.

| For me, time is the most valuable of all things. |

(1) (원급 이용) → For me, nothing _____

_____ .

(2) (비교급 이용) → For me, nothing _____

_____ .

(3) (비교급 이용) → For me, time _____

_____ .

3 다음 우리말을 주어진 〈조건〉에 맞게 영어로 옮기세요.

| 내가 문제점을 더 빨리 발견할수록, 더 빨리 그것을 바로잡을 수 있다. |
| 〈조건〉 |
| • 「the+비교급, the+비교급」 구문을 사용할 것 |
| • soon, I, the problem, fix it, can, find 를 포함할 것 |

→ _____

4 다음 글의 빈칸 (A), (B)에 괄호 안에 주어진 단어의 알맞은 형태를 쓰세요.

| I love this painting by Monet. I think it's ____(A)____ (beautiful) painting in this museum, and no other painting in the museum is ____(B)____ (valuable) than this one. |

(A) _____
(B) _____

5 다음 문장에서 어법상 틀린 두 곳을 바르게 고쳐서 문장을 다시 쓰세요.

| The Louvre is one of largest museum in the world. |

→ _____

CHAPTER

16

특수구문

| 기본 개념 & 용어 Review |

강조 특정 어구를 강조하고 싶을 때 다른 어구를 붙이거나 문장 앞으로 보낼 수 있어요.

do[does, did] + 동사원형
 강조하는 동사

It is[was] 강조어구 that ...

이때, 특정 어구를 문장 앞으로 보내면 주어와 동사의 어순이 바뀌는 **도치** 가 일어나요.

주어 + 동사 + 장소 부사구 / 부정어구

→ 장소 부사구 / 부정어구 + 동사 + 주어

동격 명사나 대명사의 의미를 다른 어구나 절이 뒤에 와서 보충해줄 수 있어요.

명사 , 명사

명사 + that절

명사 + of ~

강조, 도치

문장의 어떤 어구를 강조해서 말하고 싶을 때 다른 특정 어구를 덧붙이거나 문장 맨 앞에 보낼 수 있어요.
또한, 'It is[was] ~ that' 사이에 강조하고 싶은 말을 두기도 합니다.

A 동사의 강조

do[does, did] + 동사원형: 정말 ~하다

강조하려는 동사의 원형 앞에 조동사 do를 쓰는데 주어의 인칭과 시제에 맞게 바꿔 써요.

- **Do** *play* it.
- He **does** *resemble* his father.
- Ann said she would come, and she **did** *come*.

B It is[was] ~ that ... 강조

It is[was] ~ that ...: ···하는 것은 바로 ~이다[였다]

강조하고 싶은 어구를 It is[was] ~ that 사이에 두고 나머지는 that절로 보내요. 강조하는 (대)명사가 사람일 때는 that 대신 who[whom]를, 사물일 때는 ¹_____를 쓸 수 있어요.

- I met Ben here yesterday.
 - → **It** was *I* **that[who]** met Ben here yesterday. 주어 강조
 - → **It** was *Ben* **that[who(m)]** I met here yesterday. 목적어 강조
 - → **It** was *here* **that** I met Ben yesterday. 부사(장소) 강조
 - → **It** was *yesterday* **that** I met Ben here. 부사(시간) 강조

C 도치

강조를 위해 특정 어구를 문장 ²_____에 둘 때 주어와 (조)동사의 위치가 서로 바뀌는 것을 도치라고 해요.

❶ (장소, 방향의) 부사구 + 동사 + 주어

- *Down* **came the rain** for hours. ← The rain came down for hours.
- *At the corner* **is a library**. ← A library is at the corner.
- *There* **goes the thief**!

*there[here] 뒤 주어가 대명사인 경우 도치되지 않음. (*Here* **he comes**.)

❷ 부정어구(never, not, little, hardly 등) + (조)동사 + 주어

일반동사가 있는 문장은 「부정어구 + do[does, did] + 주어 + 동사원형」의 형태로 도치돼요.

- *Never* **was I** afraid of failure. ← I was never afraid ~.
- *Little* **did I** expect to meet him again. ← I little expected ~.
- *Hardly* **have I** seen such a huge crowd. ← I have hardly seen ~.

❸ so/neither + (조)동사 + 주어: ~도 그렇다/그렇지 않다

앞에 나온 내용의 동사가 일반동사이면 동사는 do[does, did]를 씁니다.

- I'm hungry. — **So am I.** so[neither] + be동사 + 주어
- He can sing well. — **So can I.** so[neither] + 조동사 + 주어
- I didn't see him. — **Neither did I.** so[neither] + do[does, did] + 주어

PRACTICE

STEP 1

굵은 글씨로 된 부분이 강조되도록 주어진 문장을 〈보기〉와 같이 바꿔 쓰세요.

> 〈보기〉 I **opened** the door quietly, so as not to wake my family up.
> → I <u>did open the door quietly</u>, so as not to wake my family up.

1 I **like** to cook for other people and see them enjoy my food.

→ _____ and see them enjoy my food.

2 Do you believe that miracles **happen** in reality?

→ Do you believe that _____ ?

3 Amy doesn't like action movies, but she **likes** fantasy movies.

→ Amy doesn't like action movies, but _____ .

4 She **came** to see me when I was in the hospital.

→ _____ when I was in the hospital.

> 〈보기〉 The printer was repaired **yesterday**.
> → <u>It was yesterday that the printer was repaired.</u>

5 The school is looking for **a native English teacher**.

→ _____

6 He published his first book **in 2010**.

→ _____

7 **I** have to thank you for doing such a wonderful thing.

→ _____

8 We are planning to have lunch **at the beach** on Saturday.

→ _____

STEP
2

두 문장이 같은 뜻이 되도록 so나 neither를 이용하여 문장을 완성하세요.

1 Bill already watched that movie, and I watched it, too.

= Bill already watched that movie, and _____.

2 I wasn't talking about you, and Susan was not, either.

= I wasn't talking about you, and _____.

3 All my friends can't believe that she left, and I can't, either.

= All my friends can't believe that she left, and _____.

4 Everyone laughs at my dream of being a magician, and my parents do as well.

= Everyone laughs at my dream of being a magician, and _____.

STEP
3

밑줄 친 부분이 어법상 바르면 ○표 하고 틀리면 바르게 고치세요.

1 Never did I <u>ate</u> carrots when I was little.

2 I don't know the man you are talking about, and neither <u>do</u> Jenny.

3 In the basket <u>were</u> some sandwiches and sodas.

4 I was very hungry, and so <u>was</u> my sister.

5 Look! Beyond the mountains <u>lie</u> the town.

STEP
4

우리말과 뜻이 같도록 괄호 안의 단어를 배열하여 문장을 완성하세요. (필요시 단어를 추가하거나 변형할 것)

1 나무 밑에는 그의 편지와 선물이 있었다. (letter, were, his, present, and)

→ Under the tree _____.

2 나는 어젯밤 무슨 일이 있었는지 거의 기억이 나지 않았다.

(I, what, last night, remembered, happened)

→ Little _____.

3 이 가게가 문을 닫은 것은 바로 한 달 전이다. (this store, a month, closed, ago, was)

→ It _____.

Point 01 의미가 같은 것 찾기

so, neither의 의미와 함께 쓰이는 동사의 형태에 주의하세요.

Point 02 알맞은 문장 찾기

It is[was] ~ that ...을 이용해 강조할 때는 시제와 강조하려는 대상이 무엇인지 주의 깊게 봐야 해요.

정답 및 해설 p.18

Point 01

● 다음 밑줄 친 부분과 바꿔 쓸 수 있는 것은?

A: I didn't like the movie. It was so boring.
B: I didn't like it, either. The storyline was awful.

① So do I.
② Neither do I.
③ So did I.
④ Neither did I.
⑤ Neither am I.

Point 02

● 주어진 문장의 밑줄 친 부분을 강조한 것으로 알맞은 문장은?

I had my hair cut short a month ago.

① It is a month ago who I had my hair cut short.
② It is a month ago that I had my hair cut short.
③ It was a month ago which I had my hair cut short.
④ It was a month ago that I had my hair cut short.
⑤ It was a month ago who I had my hair cut short.

Unit 40 생략, 동격, 부정, 무생물주어 구문

간결하고 명료하게 정보를 전달하기 위해 반복되는 어구를 생략하는 경우처럼, 문장을 쓸 때 의미를 잘 전달하기 위해 사용하는 다양한 방법들을 알아보기로 해요.

A 생략

❶ 반복되는 어구 생략

문맥을 이해하는 데 지장이 없다면 반복되는 어구를 생략하는 경우가 많아요.

- *The game* started at noon and ∧ finished at 4 p.m.　　반복되는 주어 생략
 (the game)

- Betty *brought* some roses and Jane ∧ some lilies.　　반복되는 동사 생략
 (brought)

- Jaden is *a famous actor*, as his father used to be ∧.　　반복되는 보어 생략
 (a famous actor)

❷ 부사절의 「주어+be동사」 생략

부사절의 주어가 주절의 주어와 일치할 때, 부사절의 「1 _____ + 2 _____」는 생략할 수 있어요.

- **When ∧ a boy**, *I* liked to ride my bicycle to school.
 (I was)

- **Though ∧ very tired**, *she* was still helping others.
 (she was)

B 동격

(대)명사 의미를 보충하거나 다시 말하기 위해 다른 명사(구)나 명사절을 뒤에 두는 것을 말해요.

❶ 명사, 명사(구)

- William Shakespeare, the great English writer of drama, was born in 1564.
 명사 └──── = ────┘ 명사구

❷ 명사+that절: ~라는 (명사)

that이 이끄는 동격절 앞에는 fact, news, idea, thought, promise 등의 명사가 자주 쓰여요.

- She denied *the fact* **that** she didn't graduate from the university.
 명사 └── = ──┘ that절

❸ 명사+of ~: ~라는 (명사)

- There's little hope **of** her passing the exam.
 명사 └── = ──┘ of 명사구

> **More** 동격의 that절 vs. 다른 여러 가지 that절
>
> 동격을 이루는 that절과 쓰임이 다른 여러 that절을 혼동하지 않아야 해요.
>
> He didn't *keep the promise* **that** he made to me. (관계대명사절)
>
> I was **so** moved by the movie **that** I saw it twice. (so ~ that절: 너무 ~해서 …한)
> └──── ≠ ────┘
>
> The teacher told us **that** the exam would be easy. (목적어 역할-명사절)

C 부정구문 **❶** 부분부정과 전체부정

부분부정은 부분적인 **3**＿＿＿＿＿이라고 생각하면 이해하기 쉬워요.

부분부정	전체부정
not ~ both (둘 다 ~인 것은 아닌)	not ~ either / neither ~
not ~ all / not ~ every (모두 ~인 것은 아닌)	not ~ any / none ~ / no ~ (아무도[아무것도] ~가 아닌)
not always (항상 ~인 것은 아닌)	not ~ at all (전혀 ~가 아닌)

+ **Not all** the passengers were rescued.　　부분부정: not all+복수명사

 = **Not every** passenger was rescued.　　부분부정: not every+단수명사

 (= Some of the passengers were rescued, but others were not.)

+ **None** of the passengers was[were] rescued.　　전체부정

 (= All the passengers were not rescued.)

+ **Neither** of us has been there before.　　전체부정

 (= Both of us have not been there before.)

❷ 수사의문문

형태는 **4**＿＿＿＿＿이지만 응답을 기대하는 것이 아니라 묻는 내용과 반대로 생각한다는 것을 반어적으로 표현하는 것이에요. 평서문보다 말하는 사람의 생각을 더 강하게 나타낼 수 있어요.

+ **Who knows?**

 (= Nobody knows.)

+ A: I'm glad you remember me.

 B: **How can I forget you?**

 (= I can never forget you.)

+ **Why shouldn't I watch the program?**

 (= I can watch the program.)

D 무생물주어 구문

사람이 아닌 무생물이 주어인 문장을 말하는데, 무생물을 주어로 해석해도 되지만 무생물을 조건, 이유, 수단 등의 부사구나 부사절로 해석하면 더 자연스러울 때가 많아요.

+ **That music** makes me happy.

 (← When I hear that music, I feel happy.)

+ **A few minutes' walk** will take you to the station.

 (← If you walk for a few minutes, you will get to the station.)

+ **What** brought you here so late?

 (← Why did you come here so late?)

PRACTICE

STEP 1

다음 문장에서 생략된 부분을 찾아 〈보기〉와 같이 표시하세요.

> 〈보기〉 When △ sad, I listen to happy songs or watch funny movies.
> I am

1 While in town, we stopped at a department store.

2 Food that looks good seems to taste better than food that does not.

3 I am happy on a rainy day but my sister is not.

4 She became an author, as her mom wanted her to be.

5 Employees will get medical treatment if injured at work.

6 You'd better wear sunscreen when participating in outdoor activities.

7 My brother can play the guitar very well, but I can't.

STEP 2

굵은 글씨로 된 부분과 동격인 곳을 찾아 밑줄 치세요.

1 **Seoul**, the capital of Korea, is my hometown.

2 **My favorite subject**, physics, is one of the most difficult subjects.

3 **The fact** that more children are becoming overweight is related to lack of physical activity.

4 **The thought** of asking others for help makes some people feel uneasy.

5 **The news** that my favorite singer will visit Korea soon makes me excited.

6 Mom made me **a promise** that she would buy me a new smartphone.

STEP 3

두 문장이 뜻이 같도록 괄호 안에서 알맞은 것을 고르세요.

1 Not everyone thinks that your way is the best way.
= [All / Not all] think that your way is the best way.

2 I took none of the pictures with my camera.
= I didn't take [any / some] of the pictures with my camera.

3 Who can say he has lived a happy life?
= [Anyone / No one] can say he has lived a happy life.

4 Not all the applicants had a chance to take part in an interview.
= [Some / None] of the applicants had a chance to take part in an interview.

5 Though first impressions can be correct or incorrect, they are surely important.
= Though first impressions are [not always / never] correct, they are surely important.

6 Some women like flowers, but others do not.
= [Every / Not every] woman likes flowers.

7 Because of vacation, all the students are absent today.
= Because of vacation, [not all / none of] the students are present today.

8 Who in the world doesn't want to be beautiful?
= [Everybody / Nobody] in the world wants to be beautiful.

9 She didn't believe all of the rumors that she had heard.
= She believed [all / some] of the rumors that she had heard.

10 You can only select either Option A or Option B.
= You can select Option A or Option B, but [none / not both] of them.

11 I couldn't understand his writing at all.
= I could understand [all / some / none] of his writing.

STEP

4

다음 밑줄 친 부분의 의미로 알맞은 것을 고르세요.

1

She is <u>not always good</u> at remembering things.

① 항상 잘한다 ② 가끔은 잘 못한다

2

They <u>didn't seem to care at all</u> about others' opinions.

① 전혀 신경 쓰지 않는다 ② 조금은 신경을 쓴다

3

<u>Who in the world would buy</u> those shoes?

① 누군가가 구입한다 ② 아무도 구입하지 않는다

STEP

5

우리말과 뜻이 같도록 괄호 안의 단어를 배열하여 문장을 완성하세요.

1 거짓말이 항상 나쁜 것은 아니다. (bad, not, are, lies, always)

→ _____.

2 그는 외계인이 존재한다는 믿음을 가지고 있다.

(exist, a belief, has, that, he, aliens)

→ _____.

3 나의 소원 중 아무것도 이루어지지 않았다. (have, wishes, my, of, come true, none)

→ _____.

4 뉴스에서 내일은 추울 것이라고 했다. (said, that, the news, cold, will be, tomorrow)

→ _____.

Point 01 쓰임이 같은 것 찾기

that은 동격절을 이끄는 것 외에도 문장에서 다양한 역할을 하므로 쓰임이 다른 that을 구별할 수 있어야 합니다.

Point 02 문장의 의미 파악하기

부정어구가 부분 부정을 나타내는지 전체 부정을 나타내는지 올바르게 해석하세요.

정답 및 해설 p.19

Point 01

● 주어진 문장의 밑줄 친 that과 쓰임이 같은 것은?

> The thought that everyone is equal is the key point in the speech.

① The soccer game that I watched yesterday was very exciting.
② He arrived so late that he couldn't enter the concert.
③ I hope that my parents will trust and support me.
④ An interesting fact is that the movie is based on a true story.
⑤ When I heard the news that he had moved away, I was very sad.

Point 02

● 다음 문장의 의미로 적절하지 않은 것은?

① None of us is happy with this result.
　→ 우리 중 아무도 이 결과에 만족하지 않는다.
② Not every student came to the seminar.
　→ 학생 전부가 세미나에 오지 않았다.
③ Not both of the food were delicious.
　→ 그 음식 둘 다 맛있는 것은 아니었다.
④ Neither of us solved the problem.
　→ 우리 중 아무도 그 문제를 풀지 못했다.
⑤ The rich are not always happy.
　→ 부유한 사람이 항상 행복한 것은 아니다.

Overall Exercises 16

[1-4] 다음 빈칸에 알맞은 말을 고르세요.

1
> I hope to travel around the world by bicycle, and _____.

① neither does he ② so is he
③ so does he ④ neither did he
⑤ so did he

2
> Everyone was not satisfied with the movie, and _____.

① so is she ② so was she
③ neither she was ④ neither did she
⑤ neither was she

3
> Some of the members agree with the opinion, but _____ member agrees with it.

① both ② not every
③ neither ④ all
⑤ none

4
> Mt. Baekdu, _____ in Korea, is famous for its beautiful scenery.

① that is the highest mountain
② is the highest mountain
③ which the highest mountain is
④ the highest mountain is
⑤ the highest mountain

[5-6] 주어진 문장의 밑줄 친 부분을 강조하는 문장을 고르세요.

5
> I met Ben in the restaurant yesterday.

① It is Ben that I met in the restaurant yesterday.
② It was Ben that I met him in the restaurant yesterday.
③ It was Ben which I met in the restaurant yesterday.
④ It will be Ben that I met in the restaurant yesterday.
⑤ It was Ben that I met in the restaurant yesterday.

6
> I lost my umbrella in the subway.

① It was in the subway I lost my umbrella.
② It is in the subway that I lost my umbrella.
③ It was in the subway which I lost my umbrella.
④ It was in the subway that I lost my umbrella there.
⑤ It was in the subway that I lost my umbrella.

7 **다음 문장에서 생략할 수 있는 부분에 괄호를 치세요.**

> When you are watching a movie in a theater, you should be quiet.

8 주어진 문장에 쓰인 콤마와 <u>다른</u> 역할을 하는 것은?

> John Miller, the International Rescue Team leader, is my role model.

① I live in New York, one of the most exciting cities in the world.
② Because it is so delicious and good for your health, I like kimchi.
③ This is my school, Gaya Middle School.
④ Have you heard of the hanbok, Korean traditional clothing?
⑤ I spent my vacation in a beautiful place, Jeju Island.

[9-10] 두 문장이 같은 뜻이 되도록 할 때 빈칸에 알맞은 말을 고르세요.

9

> Who in this world wants to be lonely?
> = _____ in this world wants to be lonely.

① Nothing
② Anything
③ Nobody
④ Everyone
⑤ Somebody

10

> Sorry, all pets are not allowed in the lobby of the hotel.
> = Sorry, _____ pets are allowed in the lobby of the hotel.

① some
② no
③ any
④ not
⑤ none

11 다음 중 빈칸에 생략된 말로 알맞은 것은?

> Some children raised their hands while _____ crossing the street.

① it is
② it was
③ they are
④ they were
⑤ they will be

12 다음 문장의 의미로 알맞지 <u>않은</u> 것은?

① While in a public place, you should not make loud noises.
 → 당신은 공공장소에 있을 때 시끄러운 소리를 내면 안 된다.
② Something expensive is not always good.
 → 비싼 것은 항상 좋지 않다.
③ The warm weather makes me sleepy.
 → 따뜻한 날씨 때문에 나는 졸리다.
④ None of the seats were empty.
 → 모든 좌석이 비어있지 않았다.
⑤ Who knows what will happen in the election?
 → 선거에서 무슨 일이 일어날지 아무도 모른다.

[13-14] 괄호 안에서 어법에 맞는 것을 골라 동그라미하세요.

13 Little [does / do] her story tell us about her life.

14 Everyone knows the fact [which / that] laughter is good medicine.

[15-17] 주어진 문장과 밑줄 친 부분의 쓰임이 같은 것을 고르세요.

15

> He prefers winter to summer, and <u>so</u> do I.

① It is <u>so</u> dark out there.
② Times have changed, and <u>so</u> have I.
③ It rained all day, <u>so</u> I didn't go out.
④ I'm <u>so</u> glad that I finished my report.
⑤ I know he was innocent as he told me <u>so</u>.

16

> I like him because of the fact <u>that</u> he is warm-hearted.

① All I know is <u>that</u> I know nothing.
② I am not sure <u>that</u> he will be on time.
③ I hope <u>that</u> we'll meet soon.
④ Most of the music <u>that</u> I listen to is jazz.
⑤ There is hope <u>that</u> we will overcome the problem.

17

> I don't know her as well as you do, but I <u>do</u> know she is a lovely person.

① That bakery smells good, <u>doesn't</u> it?
② He <u>does</u> look a lot like his father.
③ I <u>did</u> my homework this afternoon.
④ I <u>didn't</u> go anywhere all weekend.
⑤ I'm going to <u>do</u> the dishes after dinner.

18 다음 글의 밑줄 친 ①~⑤ 중에서 쓰임이 나머지 넷과 <u>다른</u> 것은?

> If you want to be successful, you should ① <u>do</u> more work than everyone else. To become a successful professional singer, I tried to ② <u>do</u> everything I could. Every day I ③ <u>did</u> sing an hour longer than anyone else I knew. I ④ <u>did</u> my best to reach my goal and now I am proud of myself and what I ⑤ <u>did</u>.

19 다음 물음에 대한 대답으로 적절한 것은?

> Who did you talk on the phone with last night?

① It was on the phone that I talked with Ted last night.
② It was I that talked on the phone with Ted last night.
③ It was Ted that I talked on the phone with last night.
④ It was last night that I talked on the phone with Ted.
⑤ It was Ted that you talked on the phone with last night.

20 다음 문장과 의미가 같도록 빈칸에 알맞은 말을 쓰세요.

> Some students brought their homework, but others didn't.

= _____ _____ student brought their homework.

Writing Exercises

서술형 만점

1 다음 우리말과 뜻이 같도록 괄호 안의 단어를 배열하여 문장을 완성하세요.

(1)
> 모든 사람이 당신을 잘 이해할 수 있는 것은 아니다.
> (all, people, can, not, you, understand, well)

→ _____ .

(2)
> 내 남동생은 달걀과 땅콩을 절대 먹지 않는다.
> (my brother, peanuts, never, does, and, eat, eggs)

→ _____

_____ .

(3)
> 모든 것을 뒤덮은 것은 바로 황사였다.
> (yellow dust, was, covered, that, everything)

→ It _____ .

2 밑줄 친 부분이 강조되도록 바꿔 쓴 문장을 완성하세요.

(1)
> The bad weather made us so depressed.

→ It _____

_____ .

(2)
> She hardly imagined that she would become world famous.

→ _____ that
she would become world famous.

3 두 문장이 의미하는 바가 같도록 빈칸에 알맞은 말을 쓰세요.

(1) All the members couldn't say anything.
= _____ _____ _____
_____ could say anything.

(2) I usually get up early, but I get up late on weekends.
= I do not _____ _____
_____ early.

4 다음 문장에서 생략할 수 있는 부분을 생략해서 문장을 다시 쓰세요.

(1)
> Although he is young, he is very wise.

→ _____

(2)
> My dad had said he would come, but he didn't come.

→ _____

(3)
> Garlic is delicious when it is cooked on the barbecue with meat.

→ _____

5 다음 대화의 밑줄 친 부분과 의미가 같도록 빈칸에 알맞은 말을 쓰세요.

> A: I'm worrying about the mid-term exam. I didn't study hard for it.
> B: I didn't study, either.

→ _____

쎄듀 본영어

1 구문 — 판매 1위 '천일문' 콘텐츠를 활용하여 정확하고 다양한 구문 학습

주어진 기호를 사용하여 문장 구조를 분석하고, 해석을 완성하시오.

주어진 기호를 사용하여 문장 구조를 분석하고, 해석을 완성하시오.

주어진 기호를 사용하여 문장 구조를 분석하시오.

우리말과 일치하도록 주어진 단어를 올바르게 배열하시오.

(끊어읽기) (해석하기) (문장 구조 분석) (해설·해석 제공) (단어 스크램블링) (영작하기)

2 문법·서술형 — 쎄듀의 모든 문법 문항을 활용하여 내신까지 해결하는 정교한 문법 유형 제공

다음 밑줄 친 부분이 어법상 알맞지 않은 세 개를 골라 바르게 고치시오.

다음 밑줄 친 부분이 어법상 올바르면 O, 어색하면 X를 선택하고 …

주어진 우리말과 일치하도록 괄호 안의 단어를 활용하여 <조건>에 맞게 영작하시오.

다음 문장에서 틀린 곳을 하나 찾아 밑줄을 긋고 이를 바르게 고치시오.

(객관식과 주관식의 결합) (문법 포인트별 학습) (보기를 활용한 집합 문항) (내신대비 서술형) (어법+서술형 문제)

3 어휘 — 초·중·고·공무원까지 방대한 어휘량을 제공하며 오프라인 TEST 인쇄도 가능

주어진 단어의 올바른 뜻 고르시오

빈칸에 들어갈 알맞은 단어를 고르시오

단어와 뜻이 일치하도록 연결하시오

(영단어 카드 학습) (단어 ↔ 뜻 유형) (예문 활용 유형) (단어 매칭 게임)

4 선생님 보유 문항 이용

(Online Test) (OMR Test)

101 Grammar Points with Sentences

내신·수능을 위한 고등 영문법 기본

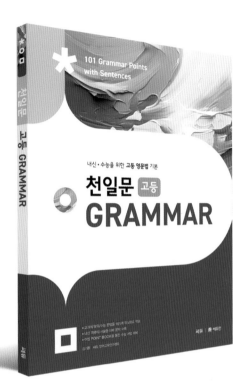

천일문 고등 GRAMMAR

① 실전에 적용하는 '예문 중점' 문법 학습

② 고등 영어 기본 문법 포인트 101개 유닛으로 구성

③ 유닛별 문법 사항 요약 제시

④ 교과서·수능·모의고사에서 엄선한 학습 최적화 예문 포함

⑤ 내신 문항 분석·반영한 양질의 'Chapter Exercises'

⑥ 개념 복습 및 수능 빈출 어법 유형을 담은 '어법 POINT BOOK' 제공

구문&문법 개념 한번에 잡는 조합!

천일문 기본 BASIC

수능 영어의 모든 구문 총망라한 체계적 구문 학습서

천일문 고등 GRAMMAR

예문을 중심으로 수능·내신에 대비하는 영문법 기본서

쎄듀

Grammar is Understanding

GRAMMAR Q

WORKBOOK

Advanced ❷

✦ Grammar is Understanding ✦

GRAMMAR Q

WORKBOOK

Advanced ❷

관계대명사 who, whom, whose

정답 및 해설 p.22

A

다음 괄호 안에서 어법에 맞는 것을 모두 고르세요.

1 We know the boy [who / whom / whose] broke the window.

2 Anna has a brother who [play / plays] the flute very well.

3 The experts help those [who / whom / whose] are suffering from allergy.

4 I know the woman [who / whom / whose] daughter works at a law firm.

5 The girls whom I saw at the party [is / are] my friend's sisters.

6 He is one of the great scientists [who / whom / whose] we all respect.

B

관계대명사가 들어갈 수 있는 곳에 〈보기〉의 관계대명사 중 알맞은 것을 골라 써 넣으세요.
(알맞은 관계대명사가 둘 이상인 경우도 있음)

〈보기〉	who	whom	whose	that

1 I saw a woman hair is longer than two meters.

2 She has two sons want to become singers.

3 The villagers had left their homes out of fear have started to return home.

4 He is the man car was stolen.

5 That is the girl they are looking for.

6 The actress I like best is Emma Watson.

7 They are the students Mr. Bates is teaching.

8 Do you see those trees leaves are very large?

C 두 문장을 관계대명사를 이용해서 한 문장으로 쓰세요.

1 The doctor likes to play the violin. His office is near my house.

→ The doctor _____ .

2 The employees lost their jobs. Their company failed.

→ The employees _____ .

3 During my trip, I met some travelers. They knew my brother.

→ During my trip, I met _____ .

4 That man over there is the chef. I told you about him.

→ That man over there _____ .

5 There are a lot of people. They have a talent in music.

→ There are _____ .

D 다음 빈칸에 공통으로 들어갈 말을 고르세요.

1
> • The boy _____ I met yesterday was Eric.
> • The girl _____ has curly hair and wears glasses is my cousin.

① who ② whom ③ whose
④ which ⑤ those

2
> • They're planning to renovate the hotel _____ design looks very old.
> • I want to introduce a friend _____ hobby is the same as yours.

① that ② those ③ whom
④ whose ⑤ who

관계대명사 which, that

A

다음 빈칸에 공통으로 들어갈 말을 고르세요.

1

> • She loves the present _____ her parents gave her.
> • The store _____ opens every day was closed today.

① whose ② who ③ whom

④ which ⑤ those

2

> • I want to have a robot _____ can talk with me.
> • Should I try to make up with a friend _____ I fought with?
> • I am proud _____ I finished the marathon.

① that ② which ③ whom

④ whose ⑤ who

B

밑줄 친 that의 역할을 〈보기〉에서 골라 그 기호를 쓰세요.

〈보기〉 ⓐ 관계대명사 ⓑ 명사절 접속사 ⓒ 지시대명사 ⓓ 지시형용사

1 We usually keep all the papers in that cabinet.

2 The research team says that they need more time to get an accurate result.

3 The company will hire a person that deals with customer complaints.

4 I don't think that's a good idea. It costs too much.

5 The autobiography that the former president wrote became a bestseller.

C

다음 두 문장을 한 문장으로 바꿀 때 빈칸에 알맞은 말을 쓰세요.

1
> The house is big enough for four people. We moved to it last week.

→ The house _____ big enough for
four people.

2
> Water is a chemical compound. It consists of oxygen and hydrogen.
>
> *compound: 화합물

→ Water is _____ .

3
> Look at the men and the monkeys. They are on the stage.

→ Look at _____ .

D

다음 우리말과 같도록 괄호 안의 단어를 배열하여 문장을 완성하세요.

1 지각한 학생들은 선생님께 그 이유를 설명해야 한다.

(are, that, late for school, students)

→ _____ must explain the reason to
the teacher.

2 그는 내게 긴 역사를 지닌 그 궁궐에 대해 말해주었다.

(a long history, which, has, the palace)

→ He told me about _____ .

3 Maya는 학교 도서관에서 빌렸던 책을 반납했다.

(borrowed, returned, which, the book, she)

→ Maya _____ from the school library.

4 나는 수영장에서 수영하고 있는 한 아이와 개 한 마리를 보았다.

(saw, that, I, were swimming, a child and a dog)

→ _____ in the pool.

관계대명사의 계속적 용법

정답 및 해설 p.22

A

관계대명사절을 이용하여 주어진 두 문장을 한 문장으로 바꿔 쓰세요. (계속적 용법으로 쓸 것)

1 I want to visit Stonehenge. It is a mysterious ring of stones.

→ I want to visit _____.

2 I met Bill's aunt. She works at the university.

→ I met _____.

3 Suho is studying English and German. He has never been abroad.

→ _____, has never been abroad.

4 Vincent van Gogh produced more than 900 paintings. They became valuable 100 years after his death.

→ Vincent van Gogh produced more than _____

_____.

5 He kept complaining about everything. It annoyed everyone.

→ _____.

B

밑줄 친 부분이 어법에 맞으면 ○, 틀리면 ✕를 하고 바르게 고치세요.

1 I ate a seafood dish, <u>was made</u> by a famous chef.

2 Kate got a good grade on the test, <u>which</u> certainly pleased her mother.

3 We didn't see Ms. Miller, <u>who</u> was in another city for a business trip.

4 I had to take a taxi, <u>that</u> was very expensive.

5 She wanted to meet Steve, <u>whose</u> brother is a famous actor.

C 다음 괄호 안에서 어법에 맞는 것을 모두 고르세요.

1 He donated all of his money, [who / which / that] surprised people around him.

2 The B-boys, [which / who / whom / that] you just danced with, are really awesome!

3 Jenny enjoys hiking on mountains, [who / which / that] refreshes her mind.

4 So far I interviewed three authors, [who / which / that] are famous for mystery novels.

5 I went to a new restaurant, [that / which / whose] staff was very kind.

6 Henry, [which / who / that] lives next door to Jim, has an expensive car.

7 Jenny didn't like the T-shirt, [that / which / whose] I gave her for her birthday.

8 My brother Tom, [who / whose / that] loves playing basketball, wants to become a basketball player.

D 우리말과 뜻이 같도록 괄호 안의 단어와 관계대명사를 이용하여 문장을 완성하세요.

1 나는 이 목걸이를 좋아하지 않는데, 그것은 나에게 너무 꽉 낀다.
(don't like, for me, tight, this necklace, too, is)

→ _____

2 Jessica는 수학 수업을 빼먹었는데, 그건 그녀에게 드문 일이다.
(skipped, is, for her, unusual, a math class)

→ _____

3 내가 가장 좋아하는 과학자는 Einstein인데, 그는 독일에서 태어났다.
(is, was born, my favorite scientist, in, Einstein, German)

→ _____

관계대명사 what

A

괄호 안에서 어법에 맞는 것을 고르세요.

1 Nobody could imagine [what / that] the magician had in his hand.

2 We don't agree with [what / which] the politician is trying to do.

3 We stayed at a local house [what / which] we had booked on a website.

4 [What / That] the movie critics say doesn't matter to me when I choose a movie to watch.

5 He gave me a ring [what / which] was once his mother's.

6 A pair of sneakers are [what / that] I received as a birthday present from my dad.

7 I want to buy a backpack [what / that] has many big pockets.

8 We believe [what / that] the teacher will give us a second chance.

B

밑줄 친 부분이 어법상 맞으면 ○표, 틀리면 ✕표하고 바르게 고치세요.

1 We'll make a plan <u>what</u> will help many people.

2 They didn't give me <u>what</u> I wanted to have.

3 <u>What</u> he found through the experiments is amazing.

4 The store sells <u>what it</u> is needed for Christmas parties.

5 She thinks <u>what</u> she will be able to get a good grade in English.

6 The meal <u>what</u> you ordered will be served in 10 minutes.

C

다음 물음에 답하세요.

1 다음 중 어법상 <u>틀린</u> 문장은?

① What I'll do is none of your business.

② Honestly, which he gave me was totally useless.

③ The judge didn't seem to believe what the witness said.

④ There are many places which are not safe for women in the city.

⑤ Think of all the things that made us exhausted during the project.

2 밑줄 친 what의 쓰임이 주어진 문장과 <u>다른</u> 하나는?

> Choose <u>what</u> you want for dinner.

① <u>What</u> customers pursue these days is originality.

② <u>What</u> she left behind was a great lesson of love.

③ I really appreciate <u>what</u> they did for me.

④ I wonder <u>what</u> the longest word is in English.

⑤ This house is <u>what</u> I have been looking for.

D

우리말과 뜻이 같도록 괄호 안의 단어를 배열하여 문장을 완성하세요.

1 내가 즐겨 보는 것은 음식 다큐멘터리이다.

(food documentaries, is, enjoy, I, watching, what)

→ _____ .

2 이 호텔 방은 내가 온라인으로 예약했을 때 기대했던 것이 아니다.

(is, what, this, not, expected, I, hotel room)

→ _____ when I booked online.

3 네가 하고 싶지 않은 것을 다른 사람이 하게 하지 마라.

(do, don't, want, you, what, to do)

→ Don't let others _____ .

Unit 27 관계부사

A

빈칸에 알맞은 말을 〈보기〉에서 골라 쓰세요.

| 〈보기〉 | when | where | why | how | which |

1 I don't want to visit the museum _____ antique dolls are exhibited.

2 The apartment _____ I recently moved into is small but comfortable.

3 These days I'm trying to find out _____ I can boost my creativity. I'll try the way my friend recommended to me first.

4 I can't remember the day _____ we had the party.

5 Do you know the restaurant _____ Jane is working?

6 Her grandfather's birthday is _____ she bought a cake today.

7 Have you ever been to the grand church _____ is located in Rome?

8 Now is _____ you should make an apology to him.

B

밑줄 친 부분이 어법상 맞으면 ○표, 틀리면 ×표하고 바르게 고치세요.

1 The road was blocked during the period when the marathon was run.

2 The bitter taste of the medicine is how children hate to take it.

3 Summer is the season most people enjoy swimming in the ocean.

4 I'm going to visit the lake that some people believe a monster lives.

5 The temple where we visited in India was very beautiful.

C

다음 물음에 답하세요.

1 다음 중 어법상 <u>틀린</u> 문장은?

① That is the house where I grew up.

② I cannot forget the time when we last met.

③ This is the village where the president was born in.

④ This is the way he solved the problem.

⑤ The stranger was sitting where I was supposed to sit.

2 다음 중 어법과 문맥상 바른 문장은?

① Let me tell you the reason when I'm leaving.

② The book is about the way how people learn a foreign language.

③ The bag where the actress carries is expensive.

④ The museum which there are famous paintings is in Paris.

⑤ He looked back on last year when he had worried about everything.

D

우리말과 같은 뜻이 되도록 괄호 안의 단어를 배열하여 문장을 완성하세요.

1 그 소녀는 무지개가 끝나는 곳에 가는 상상을 했다.

(the place, ends, the rainbow, where)

→ The girl imagined going to _____.

2 그 역사가는 2차 세계대전이 진행 중이었던 시기를 연구해 왔다.

(in progress, the period, World War II, when, was)

→ The historian has studied in _____.

3 Newton은 사물이 땅으로 떨어지는 이유를 밝히고 싶었다.

(to the ground, why, fall, the reason, things)

→ Newton wanted to figure out _____.

4 Julie는 자신이 오븐 없이 케이크를 굽는 방법을 보여주는 영상을 올렸다.

(cakes, how, without, bakes, an oven, she, shows)

→ Julie posted a video which _____.

단어, 구, 절의 연결

A

다음 괄호 안에서 어법과 문맥상 알맞은 것을 고르세요.

1 He thinks long enough before [speaks / speaking].

2 We will have heavy traffic jams [because / because of] the snow.

3 The doorbell rang [during / while] I was going upstairs.

4 [Although / Despite] bad reviews, the movie made a huge profit.

5 [In spite of / Although] she is only a teenager, she runs a company.

6 Many Koreans became interested in ants [because / because of] his book.

7 We don't mind waiting [during / while] you get ready.

8 She wrote her first book after she [visited / visiting] Cuba.

B

문맥상 빈칸에 가장 알맞은 접속부사를 〈보기〉에서 골라 쓰세요. (단, 한 번씩만 사용할 것)

〈보기〉	therefore	however	for example	otherwise	besides

1 I gave the book to Tom. _____, he didn't like it.

2 You must hurry up. _____, you'll be late for the meeting.

3 Jimmy didn't study at all. He, _____, failed the test again.

4 I don't really want to go out. _____, it seems it will rain soon.

5 Coins around the world are produced in many shapes. In India, _____, some coins have square sides.

C 다음 중 빈칸에 들어갈 말이 바르게 짝지어진 것은?

> • You must return the books to the library by tomorrow. _____, you will have to pay a fine.
>
> • Animals can feel pain, just like human beings. _____, animal testing should be banned.
>
> • The best time to visit Bangkok is between November and March because the weather isn't so hot. _____, during this period, visitors can enjoy Bangkok's best festivals.

① Nevertheless ····· Therefore ····· Furthermore
② Nevertheless ····· However ····· In fact
③ Otherwise ····· However ····· Moreover
④ Otherwise ····· Thus ····· Moreover
⑤ Likewise ····· Thus ····· In fact

D 우리말과 뜻이 같도록 〈보기〉에서 알맞은 말을 고른 후 괄호 안의 단어를 배열하여 문장을 완성하세요.

〈보기〉 during while because due to although despite

1 그녀는 운전 시험에 또 실패했기 때문에 너무 속상했다.
(her driving test, failed, she, again)
→ She was so upset _____.

2 그를 설득하려는 내 모든 노력에도 불구하고 그는 마음을 바꾸지 않았다.
(him, all my efforts, didn't change, to persuade, he)
→ _____ his mind.

3 궂은 날씨 때문에, 그날 야외 행사는 취소되었다.
(the outdoor event, canceled, the bad weather, was)
→ _____ that day.

Unit 29 등위접속사

A

밑줄 친 부분이 어법과 문맥상 바르면 ○표, 틀리면 ✕표하고 바르게 고치세요.

1 Neither my brothers nor my sister <u>eats</u> raw fish.

2 Don't waste your time, <u>or</u> you will regret it.

3 Success comes not by chance <u>but</u> through hard work.

4 My sister suffered from a fever and <u>painful</u> the other night, but is getting better now.

5 Good sleeping habits as well as healthy eating <u>gives</u> the body a good chance to heal itself.

6 I like this picture not because it was painted by a famous artist <u>and</u> because it is unique.

7 They came up with a new way not only to attract tourists but also <u>to make</u> the city a better place.

8 Be generous to others, <u>but</u> they will think you as a good person.

9 We should not ignore the older generations but <u>listening</u> to them.

10 A stranger came to me and <u>asking</u> how to go to the subway station.

11 We have to be in harmony not only with other human beings but also <u>plants</u> and animals.

12 I'll make a presentation in a simple but <u>effectively</u> way to reduce the length of this meeting.

B

다음 물음에 답하세요.

1 다음 중 어법상 틀린 문장은?

① Both her father and her mother wear glasses.

② The durian looks fresh but smells bad.

③ Either the girl or her brother have an allergy to seafood.

④ Don't touch that pot, or you'll get burned.

⑤ I not only woke up late but also forgot my books.

2 다음 중 어법상 바른 문장은?

① My dad neither drinks nor smoke.

② Work harder, or you'll get a bonus.

③ Peter as well as you is my close friend.

④ She turned off the television and going to bed.

⑤ The whole team worked very hard and active.

C

우리말과 뜻이 같도록 〈보기〉에서 알맞은 표현을 고른 후 괄호 안의 단어를 이용하여 문장을 완성하세요.

〈보기〉	not A but B	either A or B
	neither A nor B	not only A but also B

1 전화나 이메일로 제게 연락하시면 됩니다. (e-mail, phone, by)

→ You can contact me _____.

2 우리는 그 차가 마음에 들어서가 아니라 저렴해서 빌리기로 했다.

(we, it, was, liked, cheap, because, it)

→ We decided to rent the car _____.

3 그는 도서관에서도 서점에서도 그 책을 찾을 수가 없었다.

(the bookstore, at, the library)

→ He could find the book _____.

4 부모님뿐만 아니라 선생님도 내 계획에 동의하신다. (my parents, agree, my teacher)

→ _____ with my plan.

부사절을 이끄는 접속사

A

괄호 안에서 문맥상 적절한 접속사를 고르세요.

1 The audience rushed out of the hall [as soon as / so that] the concert was over.

2 He couldn't move at all [though / because] he broke his legs.

3 My father arrived [while / since] we were having dinner.

4 [Although / As] time passed, everything seemed to get better.

5 We didn't eat anything [if / until] our guests came.

6 [Though / As long as] it rained a lot, we enjoyed our vacation.

7 [Unless / When] you walk faster, you will miss the bus.

8 [Since / Even though] it snowed heavily, the station was closed.

9 The guide will lead you [so that / as long as] you can relax and enjoy the trip.

10 [Unless / Although] they are only teenagers, they can make a difference in the world.

B

다음 물음에 답하세요.

1 다음 중 문맥상 자연스럽지 <u>않은</u> 문장은?

 ① Once I find the book, I'll lend it to you.
 ② I won't give up until I accomplish my goals.
 ③ You can't travel abroad unless you don't have a passport.
 ④ When I was young, I used to ride my bike a lot.
 ⑤ As we were late for the movie, we took a taxi.

2 다음 문장의 밑줄 친 부분과 쓰임이 같은 것은?

> We went to see the play <u>as</u> it had good reviews.

① When in Rome, do <u>as</u> the Romans do.
② <u>As</u> the teacher came into the classroom, they were talking loudly.
③ <u>As</u> the temperature rises, the climate becomes more humid.
④ <u>As</u> I said before, I think the topic needs further discussion.
⑤ <u>As</u> our vacation date was changed, we have to cancel the flight reservation.

3 다음 중 밑줄 친 부분의 쓰임이 다른 하나는?

① Someone gave me a call <u>while</u> I was at the shopping mall.
② <u>While</u> she solved the problem in only five minutes, I still don't know the answer.
③ My dog comes and sits near me <u>while</u> I'm having lunch.
④ Noah saw a stranger <u>while</u> he was walking down the street.
⑤ <u>While</u> they were outside, they played badminton in the park.

C

우리말과 뜻이 같도록 〈보기〉에서 알맞은 접속사를 고른 후 괄호 안의 단어를 배열하여 문장을 완성하세요.

〈보기〉	every time	as soon as	so ~ that

1 나는 침대에 눕자마자 잠이 들었다. (lay, I, in my bed)

→ _____, I fell asleep.

2 너는 네 카드를 사용할 때마다 포인트를 얻을 수 있어.

(earn, your card, points, use, you)

→ You can _____.

3 그 파스타가 너무 짜서 나는 물을 많이 마셔야 했다.

(drink, salty, lots of, the pasta, had to, water, I, was)

→ _____.

명사절을 이끄는 접속사

A

다음을 간접화법으로 바꿔 문장을 완성하세요.

1 My sister said, "I am going to the library tomorrow."

→ My sister said _____.

2 Tony said to me, "I will do the dishes now."

→ Tony told me _____.

3 The couple said to me, "We have been married for seven years."

→ The couple told me _____.

4 Debby asked, "What will you do with these ingredients?"

→ Debby asked _____.

*ingredient: 재료

5 Matt asked her, "Why are you standing here?"

→ Matt asked her _____.

B

다음 문장에서 어법상 **틀린** 곳을 찾아 바르게 고치세요.

1 Do you know whose handwriting is that?

2 At that time, we believed that he is lying to us.

3 The teacher said that Columbus had discovered America in 1492.

4 I don't remember who was the former mayor of Seoul.

5 We learned that plants absorbed carbon dioxide during the daytime.

6 It is true whether he is going to leave this city.

C 주어진 두 문장을 한 문장으로 바꿔 빈칸을 완성하세요.

1 Would you tell me? + How do you spell your name?

→ Would you tell me _____ ?

2 Do you know? + Where is Sean from?

→ Do you know _____ ?

3 I wonder. + Why did they skip the class?

→ I wonder _____ .

4 Do you think? + What is the secret of your health?

→ _____ ?

5 Tell me. + When will she come back?

→ _____ .

D 우리말과 뜻이 같도록 괄호 안의 단어를 배열하여 문장을 완성하세요.

1 너는 누가 그 소문을 퍼뜨렸는지 아니?

(who, know, the rumor, do, spread, you)

→ _____ ?

2 문제는 내가 그들의 계획에 대해 아무것도 모른다는 것이다.

(anything, that, the problem, don't know, is, I)

→ _____ about their plan.

3 나는 자전거를 수리할 만큼 내가 충분한 돈을 갖고 있는지 확실하지 않다.

(I, enough, sure, have, I'm, money, not, if)

→ _____ to repair my bike.

4 너는 네 단점이 뭐라고 생각하니?

(your, do, weakness, you, is, what, think)

→ _____ ?

A

다음 문장을 분사구문으로 바꿔 쓰세요.

1 As she is a foreigner, she needs a visa to visit the country.

→ _____, she needs a visa to visit the country.

2 While he was walking to school, he met his old friend by accident.

→ _____, he met his old friend by accident.

3 She stood on the street corner as she talked to her friend.

→ She stood on the street corner, _____.

4 As she pointed to her family picture, she told us about it.

→ _____, she told us about it.

5 When you demand a refund, you need a receipt.

→ _____, you need a receipt.

6 As Ben was thinking about his parents, he wrote a letter.

→ _____, Ben wrote a letter.

7 Because the sky was clear, we could see the stars.

→ _____, we could see the stars.

8 As soon as she met her old friend, she burst into tears.

→ _____, she burst into tears.

*burst into tears: 울음을 터뜨리다

9 As the machine is very old, it makes loud noises.

→ _____, the machine makes loud noises.

10 He heard the news and dropped his cup in surprise.

→ _____, he dropped his cup in surprise.

B 다음 중 밑줄 친 부분과 바꿔 쓸 수 있는 것으로 가장 적절한 것을 고르세요.

1 Seeing a police officer, they immediately ran away.
① When they saw a police officer
② While they saw a police officer

2 Living close to a beach, I swim and fish a lot.
① Before I live close to a beach
② Since I live close to a beach

3 Listening to lively music, I did the dishes.
① Since I was listening to lively music
② While I was listening to lively music

4 Being interested in space, he decided to be an astronaut.
① As he was interested in space
② While he was interested in space

C 우리말과 뜻이 같도록 괄호 안의 단어를 배열하여 분사구문을 완성하세요.
(필요시 단어의 형태를 바꿀 것)

1 그들은 악수를 하고 나서 작별인사를 했다. (hands, shake)

→ _____, they said goodbye.

2 그 마라톤 대회는 아홉 시에 시작해서 열두 시에 끝날 것이다. (twelve, finish, at)

→ The marathon will start at nine, _____.

3 내 친구는 나를 너무 오래 기다려서 화가 났다. (for, long, wait for, too, me)

→ _____, my friend became upset.

4 오렌지는 비타민이 가득해서 건강에 좋다. (vitamins, full of, be)

→ _____, oranges are healthy.

5 우리 가족은 함께 식사를 하는 동안에 대화를 많이 한다. (a meal, together, have)

→ _____, my family talks a lot.

주의해야 할 분사구문

A

다음 문장을 분사구문으로 바꿔 쓰세요.

1 Since she was treated unfairly, she was disappointed.

→ _____, she was disappointed.

2 Because I don't have brothers or sisters, I sometimes feel lonely.

→ _____, I sometimes feel lonely.

3 We were served by the waiter, and we left a tip.

→ _____, we left a tip.

4 I know many neighbors as I have lived here for a long time.

→ I know many neighbors, _____.

5 Since the scientist didn't give up his study, he succeeded in it.

→ _____, the scientist succeeded in it.

6 When the goods are ordered, they are delivered within a week.

→ _____, the goods are delivered within a week.

7 As the museum is visited by many people, it is so crowded.

→ _____, the museum is so crowded.

B

괄호 안에서 어법에 맞는 것을 고르세요.

1 [Writing / Written] in easy language, her poetry can be understood by anyone.

2 [Feeling not / Not feeling] well, she stayed home all day.

3 [Being seen / Having seen] from the sky, everything looks small.

4 [Being learned / Having learned] Spanish, she could understand the movie.

5 [Attracting / Attracted] by the advertisement, many people buy products.

C

다음 우리말과 뜻이 같은 것을 고르세요.

1
> 그 선수는 메달을 받고서 기쁨의 눈물을 흘렸다.

① Gave the medal, the player cried for joy.
② Giving the medal, the player cried for joy.
③ Given the medal, the player cried for joy.
④ Having giving the medal, the player cried for joy.
⑤ Having given the medal, the player cried for joy.

2
> 나는 Susan을 잘 몰라서 그녀가 무엇을 좋아하는지를 모른다.

① Knowing not Susan well, I don't know what she likes.
② Not known Susan well, I don't know what she likes.
③ Not knowing Susan well, I don't know what she likes.
④ Having not knowing Susan well, I don't know what she likes.
⑤ Being not known Susan well, I don't know what she likes.

D

우리말과 뜻이 같도록 괄호 안의 단어를 배열하여 분사구문을 완성하세요. (필요시 단어의 형태를 바꿀 것)

1 나는 방에 머무르지 않을 때 불을 항상 끈다. (the room, not, use)

→ _____, I always turn the light off.

2 그 집은 높은 언덕에 위치해서 멋진 경관을 가진다. (place, a high hill, on)

→ _____, the house has a great view.

3 전날 밤에 잘 자고 났더니 기분이 훨씬 좋아졌다. (sleep, the night before, well)

→ _____, I felt much better.

4 상자들은 밧줄에 묶인 후에 트럭으로 운반될 것이다. (with, tie, ropes)

→ _____, the boxes will be carried on a truck.

if 가정법 과거/과거완료

정답 및 해설 p.23

A

주어진 문장을 가정법으로 바꿔 쓸 때, 빈칸에 들어갈 말을 쓰세요.

1 As I am tired, I don't go outside to exercise.

→ If I _____ tired, I _____ outside to exercise.

2 As he doesn't remember Kelly, he doesn't say hello to her.

→ If he _____ Kelly, he _____ hello to her.

3 I don't have enough money, so I cannot buy his present.

→ If I _____ enough money, I _____ his present.

4 Because it rained, we didn't have a great holiday.

→ If it _____, we _____ a great holiday.

5 As Jack is not here, I cannot ask him for advice.

→ If Jack _____ here, I _____ him for advice.

6 As I didn't arrive home late, my parents didn't get angry.

→ If I _____ home late, my parents _____
angry.

7 As she isn't tall, her hands don't reach the top shelf.

→ If she _____ tall, her hands _____
the top shelf.

8 Because they didn't prepare for the test, they didn't pass it.

→ If they _____ for the test, they _____ it.

9 Because we didn't see the map, we spent an hour looking for the
building.

→ If we _____ the map, _____ an hour
looking for the building.

10 As it was very windy, we didn't enjoy the day at the beach.

→ If it _____ very windy, we _____
the day at the beach.

B 괄호 안에서 어법에 맞는 것을 고르세요.

1 A: Steve can never remember the names of people he meets.

B: Right. It would be better if he [talks / talked] less and [listens / listened] more.

2 A: How would you spend the money if you [win / won] the lottery?

B: I would buy a nice house with a swimming pool.

3 A: Hey, do you know any good music? I'm sick of listening to the radio on the way to school.

B: You like hip hop, don't you? I recommend you listen to this album if you [like / liked] that sort of music. It is really good.

4 A: Thank you for coming, Sara. Where's Matt? Isn't he coming?

B: He has a bad fever. If he [feels / felt] well, he [will be / would be] here.

C 우리말과 뜻이 같도록 괄호 안의 단어를 이용하여 문장을 완성하세요.
(필요시 단어의 형태를 알맞게 변화시킬 것)

1 그 가게에서 신용카드를 받아주었다면 나는 그 청바지를 샀을 텐데.

(accept, the store, credit cards, the jeans, buy, will)

→ If _____ .

2 오늘이 일요일이라면 나는 잠을 더 잘 텐데. (be, Sunday, sleep more, it, may)

→ I _____ today.

3 내가 마술사라면 사람들을 놀라게 할 수 있을 텐데.

(people, surprise, a magician, can, be)

→ If _____ .

4 만약 네가 내 입장이라면 무엇을 하겠니? (be, do, in my place, will)

→ What _____ if _____ ?

35

I wish/as if/Without[But for] 가정법

정답 및 해설 p.24

A

괄호 안의 단어를 어법과 문맥에 알맞은 형태로 바꿔 쓰세요.

1 A: How many brothers and sisters do you have?

B: I am an only child. I wish I _____ a sister. (have)

2 A: Did you watch the soccer game with Japan?

B: I wish I _____ that game, but I was working when it was on TV. (watch)

3 A: You act as if you _____ my mother. (be)

B: Hey, I'm your best friend. I'm just worried about you.

4 A: The museum closes at 6 p.m.

B: I wish you _____ me sooner. It's 5:30 now. (tell)

5 A: Do you have any allergies?

B: Yes, I'm allergic to peanuts. I wish I _____ them. (can, eat)

6 A: Did you have a lot of fun last weekend?

B: Yes, we did. I wish you _____ on the trip with us. (go)

B

다음 대화의 빈칸에 가장 적절한 말은?

> A: I thought it would be warm today, but it's cold.
>
> B: Yeah, it's freezing. _____

① I wish I have a muffler and gloves.

② I wish I had a muffler and gloves.

③ I wish I had had a muffler and gloves.

④ I wish I have had a muffler and gloves.

⑤ I wish I didn't have a muffler and gloves.

C

다음 물음에 답하세요.

1 다음과 같이 주어진 내용을 한 문장으로 표현할 때 빈칸에 알맞은 것은?

> Jisu kept correcting my English pronunciation. But she is not an English expert.
> → Jisu acted _____.

① as if she is an English expert

② as if she were an English expert

③ as if she has been an English expert

④ as if she were not an English expert

⑤ as if she hasn't been an English expert

2 다음 중 어법상 <u>틀린</u> 문장은?

① I wish you lived here with us in Korea!

② But for the information, we could not have chosen the best option.

③ I wish I had cleaned the bathroom yesterday.

④ Sometimes, she looks as if she were very sad.

⑤ It's time we change to a new internet service provider.

D

우리말과 뜻이 같도록 괄호 안의 단어를 이용하여 문장을 완성하세요.

1 그는 마치 나를 좋아하는 것처럼 행동했다. (act, like)

→ He _____.

2 크리스마스에 눈이 많이 오면 좋을 텐데. (a lot, snow, it, on Christmas)

→ I wish _____.

3 범죄가 없다면 세상은 평화로울 텐데. (peaceful, crime, will, the world, be)

→ Without _____.

원급을 이용한 비교

A

괄호 안에서 어법에 맞는 것을 고르세요.

1 Your dog is as [friendly / more friendly] as mine.

2 Mr. Pitt's lecture was not as easy [as / than] Ms. Kim's.

3 I usually get up as [early / earlier] as my father.

4 If you have a toothache, visit a dentist as soon as [can / possible].

5 My new computer is three [more / times] as fast as the old one.

6 We should use plastics as [little / less] as possible to protect the environment.

7 The story of the book feels as [really / real] as our own life.

8 The secret to happiness is to laugh as much as you [can / possible].

9 Too much exercise isn't as [good / well] as too little exercise.

10 Jihun can speak English as [fluent / fluently] as native speakers.

11 David received [twice as / as twice] many points as Jane.

12 I want to spend as [much / more] time as possible with my family.

B 다음 우리말과 뜻이 같은 문장을 고르세요.

1

일본의 인구는 한국의 인구보다 2배 이상 많다.

① Japan's population is over two times as large as Korea.
② Japan's population is as large as over two times Korea's.
③ Japan's population is as over two times large as Korea's.
④ Japan's population is over two time as large as Korea.
⑤ Japan's population is over two times as large as Korea's.

2

그 영화는 원작 소설만큼 인기를 얻지 못했다.

① The movie was as popular as its original novel.
② The movie was not as popular as its original novel.
③ The movie was so popular as its original novel.
④ The original novel was as popular as its movie.
⑤ The original novel was not so popular as its movie.

C 다음 문장을 주어진 〈조건〉에 맞게 바꿔 완성하세요.

1

〈조건〉 밑줄 친 부분을 다섯 단어로 쓸 것

I tried to finish my homework <u>as soon as possible</u>.

→ I tried to finish my homework _____.

2

〈조건〉 원급 구문을 사용해서 한 문장으로 쓸 것

My cousin is 150cm tall. But I am 155cm tall.

→ My cousin is _____.

비교급을 이용한 비교

정답 및 해설 p.24

A

괄호 안에서 어법과 문맥상 알맞은 것을 고르세요.

1 My new shoes are [so expensive / more expensive] than the old ones.

2 Taking the train will be [fast / faster] than driving a car.

3 You know [a lot / very] more about planes than me.

4 These days I walk more and eat [little / less] than usual.

5 The internet service has become [good / better] and better.

6 The more careful we are, the [more / much] accidents we can prevent.

7 The restaurant became [much / more] popular than last month.

8 Do you have any [small / smaller] ones than these blue shoes?

9 I think my eyesight got [many / much] worse than before.

10 As winter approached, the days grew [short / shorter] and shorter.

B

밑줄 친 부분 중 어법상 틀린 것을 찾아 바르게 고치세요.

1 Popcorn is ① expensive in movie theaters than in grocery stores. However, its sales are getting ② higher and higher. Many people have it ③ more in the theaters than in any other place.

2 This semester I'm taking ① more difficult classes than last semester. My teacher's advice on taking notes will be ② very more helpful when I prepare for my exams. The more you practice it, the ③ better your studying will be.

C 다음 중 어법상 바르지 <u>않은</u> 문장의 개수로 알맞은 것은?

> a. My father came home earlier than I today.
> b. The restaurant was pretty more expensive than I thought.
> c. Amy and Sue are twins, but Amy is taller than Sue.
> d. My final exam score is higher than Jisu this time.
> e. The Earth is getting hotter and hotter due to pollution.
> f. More nervous I felt, the more mistakes I made.
> g. Daniel went to the theater more often than I was.

① 6개 ② 5개 ③ 4개 ④ 3개 ⑤ 2개

D 우리말과 뜻이 같도록 괄호 안의 단어를 배열하여 문장을 완성하세요. (필요시 단어의 형태를 바꿀 것)

1 빛은 소리보다 훨씬 더 빠르게 이동한다. (sound, much, travels, than, light, fast)

→ _____

2 나의 건강은 점점 더 좋아지고 있다. (good, health, is, and, good, my, getting)

→ _____

3 나는 엄마보다 요리를 훨씬 더 잘한다. (cook, than, my, even, I, mom, good)

→ _____

4 그녀는 나이가 들수록 자신의 아빠와 더 많이 닮아졌다.

(old, more, she, her, resembled, the, became, father, she, the)

→ _____

Unit 38

최상급을 이용한 비교

A

괄호 안에서 어법에 맞는 것을 고르세요.

1 No other thing is [more / most] efficient than regular exercise for health.

2 Many students say that Monday is the [more / most] stressful day of the week.

3 The movie was chosen as one of the best [movie / movies] of the year.

4 I recommend this book [more / most] strongly than any other book to you.

5 No other person influences my life as [much / more] as my mom.

6 He played [better / best] than any other player in the match.

B

괄호 안의 단어를 알맞게 배열하여 최상급의 의미를 나타내는 문장을 완성하세요.
(필요시 단어의 형태를 바꿀 것)

1 (bad, score, one, the, of)

→ I got a bad score. It was _____ in my school career.

2 (delicious, no, other, as, as, food, is)

→ _____ my mom's.

3 (good, ever, the, that, I've, had, experience)

→ I met my favorite actor. It was _____.

4 (the, great, one, invention, in history, of)

→ The Internet is _____.

5 (population, any, country, large, than, other, a)

→ China has _____ in the world.

C

다음 중 주어진 문장과 의미가 <u>다른</u> 하나를 고르세요.

1

남극이 가장 추운 곳이다.

① No other place is colder than the South Pole.

② The South Pole is colder than any other place.

③ No other place is as cold as the South Pole.

④ The South Pole is the coldest of all the places.

⑤ The South Pole is as cold as any other place.

2

나는 사람들을 만나는 것이 가장 재미있다.

① Nothing is more interesting to me than meeting people.

② For me, nothing is as interesting as meeting people.

③ I have more interest in other things than meeting people.

④ Meeting people is the most interesting thing to me.

⑤ Meeting people is more interesting to me than any other thing.

D

다음 밑줄 친 부분이 어법상 바른 것을 고르세요.

1 ① She is the <u>bad</u> dresser I've ever seen.

② No one in our class is <u>smartest</u> than Junho.

③ This is <u>more difficult</u> puzzle of all the games.

④ My dad is <u>the busiest</u> than any other family member.

⑤ No other strawberry cake is as <u>delicious</u> as this one.

2 ① Nobody got <u>higher</u> grades as David in my class.

② No one got <u>the highest</u> grades than David in my class.

③ David got <u>the highest</u> grades in my class.

④ David got <u>the highest</u> grades than any other student in my class.

⑤ David got <u>the most highest</u> grades in my class.

A

굵은 글씨로 된 부분이 강조되도록 주어진 문장을 〈보기〉와 같이 바꿔 쓰세요.

〈보기〉 The festival was wonderful, and we all **enjoyed** it.
→ The festival was wonderful, and <u>we all did enjoy it.</u>

1 If we **finish** the race, there will be a great prize for us.

→ _____, there will be a great prize for us.

2 Most people didn't feel anything, but I **felt** the earthquake.

→ Most people didn't feel anything, but _____.

3 The teacher **knows** his students had trouble with each other.

→ _____.

4 The largest onion on record **weighed** over 4.5 kilograms.

→ _____.

〈보기〉 I found **an old coin** beneath the carpet.
→ <u>It was an old coin that I found beneath the carpet.</u>

5 **The coach of the team** proposed a new plan.

→ _____.

6 A car accident happened **on that road** today.

→ _____.

7 Jim enjoys **swimming** on weekends with his friends.

→ _____ with his friends.

8 I decided I would learn Japanese **a year ago**.

→ _____.

B 괄호 안에서 어법과 문맥상 자연스러운 것을 고르세요.

1 I do [worry / worried] about my health and have started exercising recently.

2 A: What kind of TV program do you like best?
B: I love crime TV programs and so [do / does / did] all my friends.

3 Here [the book is / is the book] that you mentioned to me last week.

4 It's true that he [do / does] always say something interesting.

5 I haven't eaten after 7 p.m., and [so / neither] have I drunk anything since then.

6 A: I heard that you went on a vacation to Da Nang. How was it?
B: It was great! Never [I have / have I] seen such beautiful scenery.

7 Down [the rain came / came the rain] like a waterfall.

C 밑줄 친 부분 중 어법상 틀린 것을 찾아 번호를 쓰고 바르게 고치세요.

1 When young, little ① we did ② realize the importance of learning. But ③ as we were growing up, we got to know how important it is.

() → _____

2 Never ① said my parents to me that I should study harder. They always said ② there are more important things ③ than studying.

() → _____

3 Hardly could they ① noticed that a cat ② was following behind ③ them.

() → _____

4 As ① interested in helping others, she ② does ③ volunteers at the hospital these days.

() → _____

생략, 동격, 부정, 무생물주어 구문

A 다음 문장에서 생략할 수 있는 부분에 괄호를 치세요.

1 Catch me if you can catch me.

2 My family will go to the movie, but I won't go to the movie.

3 While I was in the room, I didn't speak with anyone.

4 You can borrow my book, if you want to do so.

5 When she was young, she was popular in school.

6 While running into the classroom, she slipped and she fell on the floor.

7 A: I think Messi is the best soccer player ever.
 B: Yes, he really is the best soccer player ever.

B 괄호 안에서 어법과 문맥상 자연스러운 것을 고르세요.

1 [All / Not all] spiders are dangerous, but it's better to be careful.

2 Dad has taught us that [none of / not every] idea succeeds.

3 [Both / Not both] Sumin and Suji are my cousins. Only Suji is my cousin.

4 We had a hard time ordering food because [any / none] of us could read the French menu.

5 Both shirts were nice, but I bought [either / neither].

6 We can save energy by turning on the lights only when [needed / they needed].

7 At the top of the mountain [a flag is / is a flag].

C

밑줄 친 부분 중 어법상 틀린 것을 골라 번호를 쓰고 알맞게 고치세요.

1 ① Though they poor, they are happier than any other ② couple, and even the richest man cannot buy ③ their happiness and love.

() → _____

2 Hardly ① does she speak, ② when she heard the news ③ that her friend got into an accident.

() → _____

3 Dubai International Airport was ① the largest airport in the world when ② it completed, and it ③ could also become the busiest in the world.

() → _____

4 I understand why my teacher made me ① sit at a different desk. I ② did behave badly and ③ so Mary did.

() → _____

D

다음 우리말과 뜻이 같도록 〈보기〉에서 알맞은 부정어구를 고른 후 괄호 안의 말을 이용하여 문장을 완성하세요. (필요시 단어의 형태를 알맞게 변화시킬 것)

〈보기〉	none of	not every	not always	not ~ at all

1 모든 질문에 답이 있는 것은 아니다. (question, have an answer)

→ _____

2 바디 랭귀지가 항상 이해하기 쉬운 것은 아니다.

(body language, easy to understand, be)

→ _____

3 네가 오늘 사 온 채소들은 전혀 신선하지 않다.

(the vegetables, you, buy, that, be, today, fresh)

→ _____

4 손님 중 아무도 제시간에 도착하지 않았다. (the guests, arrive on time)

→ _____

MEMO

MEMO

MEMO

Grammar is Understanding!

Starter 1,2

Intermediate 1,2

Advanced 1,2

쎄듀 초·중등 커리큘럼

	예비초	초1	초2	초3	초4	초5	초6
구문		천일문 365 일력 \| 초1-3 \ 교육부 지정 초등 필수 영어 문장		초등코치 천일문 SENTENCE \ 1001개 통문장 암기로 완성하는 초등 영어의 기초			
문법					초등코치 천일문 GRAMMAR \ 1001개 예문으로 배우는 초등 영문법		
			왓츠 Grammar			Start (초등 기초 영문법) / Plus (초등 영문법 마무리)	
독해				왓츠 리딩 70 / 80 / 90 / 100 A / B			쉽고 재미있게 완성되는 영어 독해력
어휘			초등코치 천일문 VOCA&STORY \ 1001개의 초등 필수 어휘와 짧은 스토리				
		패턴으로 말하는 초등 필수 영단어 1 / 2		문장 패턴으로 완성하는 초등 필수 영단어			
ELT	Oh! My PHONICS 1 / 2 / 3 / 4		유·초등학생을 위한 첫 영어 파닉스				
		Oh! My SPEAKING 1 / 2 / 3 / 4 / 5 / 6 \ 핵심 문장 패턴으로 더욱 쉬운 영어 말하기					
		Oh! My GRAMMAR 1 / 2 / 3 \ 쓰기로 완성하는 첫 초등 영문법					

	예비중	중1	중2	중3
구문	천일문 STARTER 1 / 2			중등 필수 구문 & 문법 총정리
문법	천일문 GRAMMAR LEVEL 1 / 2 / 3			예문 중심 문법 기본서
	GRAMMAR Q Starter 1, 2 / Intermediate 1, 2 / Advanced 1, 2			학기별 문법 기본서
	잘 풀리는 영문법 1 / 2 / 3			문제 중심 문법 적용서
	GRAMMAR PIC 1 / 2 / 3 / 4			이해가 쉬운 도식화된 문법서
			1센치 영문법	1권으로 핵심 문법 정리
문법+어법		첫단추 BASIC 문법·어법편 1 / 2		문법·어법의 기초
문법+쓰기	EGU 영단어&품사 / 문장 형식 / 동사 써먹기 / 문법 써먹기 / 구문 써먹기			서술형 기초 세우기와 문법 다지기
				올씀 1 기본 문장 PATTERN \ 내신 서술형 기본 문장 학습
쓰기	거침없이 Writing LEVEL 1 / 2 / 3			중등 교과서 내신 기출 서술형
		중학 영어 쓰작 1 / 2 / 3		중등 교과서 패턴 드릴 서술형
어휘	신간 천일문 VOCA 중등 스타트/필수/마스터			2800개 중등 3개년 필수 어휘
	어휘끝 중학 필수편		중학 필수어휘 1000개 어휘끝 중학 마스터편	고난도 중학어휘 +고등기초 어휘 1000개
독해	신간 ReadingGraphy LEVEL 1 / 2 / 3 / 4			중등 필수 구문까지 잡는 흥미로운 소재 독해
		Reading Relay Starter 1, 2 / Challenger 1, 2 / Master 1, 2		타교과 연계 배경 지식 독해
		READING Q Starter 1, 2 / Intermediate 1, 2 / Advanced 1, 2		예측/추론/요약 사고력 독해
독해전략		리딩 플랫폼 1 / 2 / 3		논픽션 지문 독해
독해유형		Reading 16 LEVEL 1 / 2 / 3		수능 유형 맛보기 + 내신 대비
		첫단추 BASIC 독해편 1 / 2		수능 유형 독해 입문
듣기	Listening Q 유형편 / 1 / 2 / 3			유형별 듣기 전략 및 실전 대비
		쎄듀 빠르게 중학영어듣기 모의고사 1 / 2 / 3		교육청 듣기평가 대비